IMAGES
*of America*

# DOWNERS GROVE
## REVISITED

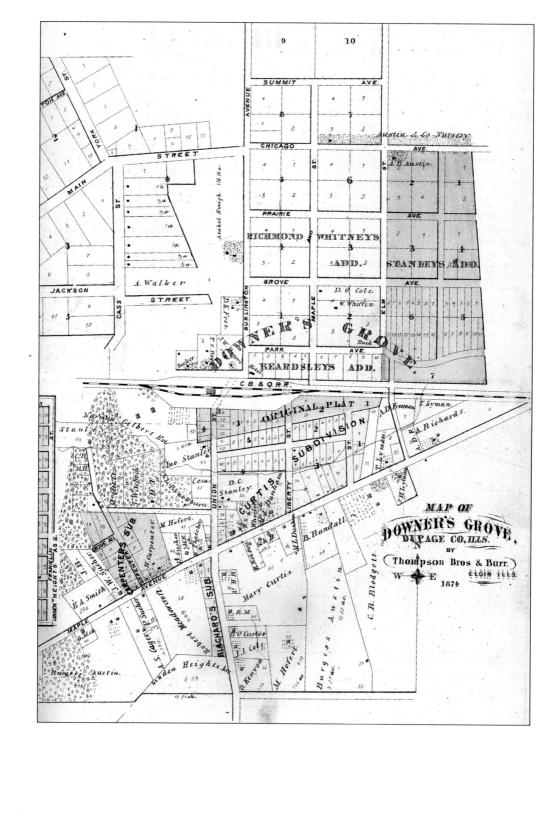

MAP OF
# DOWNER'S GROVE,
DuPage Co., Ills.
BY
Thompson Bros & Burr.
ELGIN ILLS.
1874

IMAGES
*of America*

# DOWNERS GROVE
## REVISITED

Montrew Dunham

ARCADIA
PUBLISHING

Published by Arcadia Publishing
Charleston, South Carolina

Printed in the United States of America

Library of Congress Catalog Card Number: 2003110373

For all general information contact Arcadia Publishing at:
Telephone 843-853-2070
Fax 843-853-0044
E-mail sales@arcadiapublishing.com
For customer service and orders:
Toll-Free 1-888-313-2665

Visit us on the Internet at www.arcadiapublishing.com

*To all who call Downers Grove home*

The cover photograph is of the Downers Grove Plowboys campaigning for Benjamin Harrison. All photographs, not otherwise credited, are from the collection of the Downers Grove Historical Society.

# CONTENTS

# ACKNOWLEDGMENTS

My deepest appreciation to the Downers Grove Historical Society for making their collections, photographs, and source materials available for this book and for their enthusiastic support of the project. I would like to thank individually the members of the board of directors: Greg Evans (President of the Board), Joan Read, Evelyn Poulin, Jane Pugh, Frank Betenia, Mary McNamara, Katie Blanchard, and most especially Phyllis Betenia.

My heartfelt thanks to Mark Harmon (Supervisor of the Downers Grove Park District Museum), Evelyn Zack, Jaime Hoeland, and Julia Kemerer for all their assistance and cooperation in accessing the source materials and photographs.

I am also deeply indebted to all the individuals and organizations who provided information, source materials, and photographs for this work.

To: Doris and John Mochel Jr., Ed Bunting Jr., Mike Baker, Bob Shoger, Ken Rathjke, Bob Jensen, Linda Kunze, Linda McLaughlin, Mary Scalzetti, Faith Behr, Kristine Liptrot, Lorie and Tom Annarella, Ernie and Kay Smith, Bill and Joan Hannan, Helen Myers, Virginia Stehney, Greg and Grace Beggs, Betty Bonney, Bea Waring, Louise Stebbing, Helen Hartman, George Johnson, Carol Wandschneider, Elaine Berberich, Christopher Bowen, Gene Poulin, the Downers Grove Park District, Carol Tapio, the *Downers Grove Reporter*, Joe De Rosier, Mayor Brian Krajewski and the Downers Grove Village Council, Samantha Gleisten, Joan Wilson, Betty Cheever, Sue Vineyard, Midwestern University, Karen Johnson, Ken Morgan, Lt. Lee Hahn, Cathy Schuster, Bruce Swanson, Ned Lopata, Marsha Giesler, Amy Balicki, Mary Ann Bokholdt, Julianne Coughlin, Bob Arehart, the Indian Boundary YMCA, and Judy Ellertson, my thanks!

# INTRODUCTION

Downers Grove is a village of nearly 50,000 residents in the southeastern part of DuPage County, some 22 miles west of Chicago. In 1832, the land that was to become the site of Downers Grove was an endless stretch of fertile prairie broken only by an occasional grove of trees. The oak tree grove, which attracted Pierce Downer to the place, stood tall and straight on a slight knoll. A short distance to the south, unseen by Downer through the verdant prairie grasses, was a regal stand of maple trees where the Indians had come for maple sugaring for many years.

The first sale of Indian lands in Northern Illinois had been made to the United States Government in August, 1816 for a 10-mile corridor of safe transport for both white settlers and Indians from the headwaters of the Illinois River to Lake Michigan in Chicago. By 1835, less than 20 years later, the United States Government owned all the former holdings of the Potawatomies. The northern boundary line of the corridor was from the Fox River on the west, more or less following the Illinois River, on to Lake Michigan in Chicago; ten miles southeast of the northern boundary, the southern boundary started at the Kankakee River on the west, running parallel to the northern boundary, to Lake Michigan. The northern most boundary of this corridor, the Indian boundary, goes through present-day Downers Grove on a diagonal from the southwest at Sixty-third Street to Fifty-fifth Street at Carpenter and on through to Lake Michigan.

This corridor proved to be more than a highway of safety for white settlers and Indians but also presented the opportunity for a future water route through the United States. This water route from New York to New Orleans was made possible by the Erie Canal which connected the Hudson River to Lake Erie, and the Illinois-Michigan canal which connected Lake Michigan to the Illinois River.

In April of 1818, Nathaniel Pope, the delegate of the territory in Washington, received a petition from the legislature to request that Illinois be admitted to the Union. As instructed, Pope introduced the bill to Congress, however with two amendments, which he had added. The bill, with the amendments, was passed on April 14, 1818, and was approved by President James Monroe on April 18, 1818.

The first amendment provided that three percent of the money received from the sale of public land would be used for schools and the second, by far the more important, established the northern boundary of Illinois at the 41 degree, 32 parallel rather than the southern shore of Lake Michigan adjacent to northern Indiana.

These amendments made all the difference to the history of Illinois. It gave Illinois a lake port and the metropolis of Chicago! In addition it gave Illinois the fourteen northern Illinois counties, including the county of DuPage. It also made possible the Illinois-Michigan canal and the Illinois Central Railroad. It appears that Nathaniel Pope did this on his own, and very probably changed the history of the nation. It certainly changed the history of the Village of Downers Grove!

In those early days the settlement consisted of a few pioneers on the prairie. Most of the early settlers were from New England and New York State, with the grit and determination to carve out a livelihood from the wilderness. Together they formed a community with a spirit of helping one another. They made roadways out of Indian trails, built schools and churches, and dedicated a pasture for a cemetery.

Not only did they help one another, they were hospitable to newcomers to the Village, and also to those travelers passing through, including the fleeing slaves from the south and west. Many of these staunch villagers were strong abolitionists and their homes became stations on the Underground Railroad, providing safe haven for the fugitives on their way to Canada.

In 1860, a group of young men, calling themselves "the Plowboys" gathered to campaign for Abraham Lincoln. Soon after, when the Civil War broke out, these men and boys of the Village marched off to war. There wasn't a family left untouched, and many of the soldiers came back wounded or not at all.

In 1865, when the veterans returned, they found a village, which was very changed. And of course, the biggest change of all was the coming of the CB&Q Railroad. At first most of the trains carried livestock and grain, with only a couple of commuter trains each day, but by 1875 there were several commuter trains each day and the travel time was only 1 hour and 20 minutes from Downers Grove to Chicago. Times were changing and for the first time many of the men had businesses in Chicago.

The 1890s brought all the comforts of home, when the Village, which the citizens fondly called "the Grove," had a water works, electric lights, and telephones! When the centennial rolled around in 1932, the Village had a big celebration and called it "The Spirit of the Grove." That "spirit" embodied the friendliness and helpfulness that had always been typical in the Village.

The Village continued to grow and grow beyond anything those first settlers could have imagined. In these 170 years or so, Downers Grove has grown from a few log cabins in the wilderness to a town of many homes, from a few settlers to a population of some 50,000 inhabitants. With the excellent rail service, and the interstate highways leading to the metropolis of Chicago and connecting Downers Grove with the towns to the north, south, and west, businesses have expanded and new businesses arrived. Industrial parks have been built, as have huge office complexes and shopping centers. Though Downers Grove has grown into a cosmopolitan center, the Village has not outgrown the friendliness of that special "spirit," which has characterized this community throughout the years.

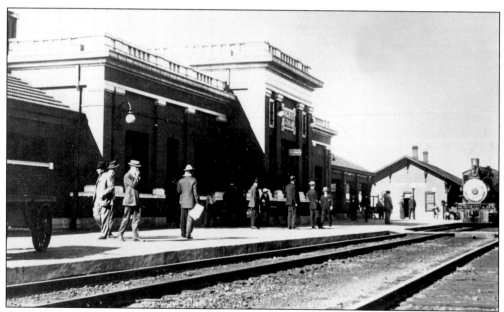

COMMUTERS. Down at the station, early in the morning, commuters gather, newspapers in hand, for their hour or so ride into the city. The original Downers Grove Train Station, built in 1865, is at the far right of the photo where the locomotive is approaching. The new station, at the left front, was constructed in 1912. With the building of the new station the old station became a freight station. The old station was razed in 1948 and the space is used for parking.

# One

# THE PIONEERS
# 1832–1850

As far as the eye could see the tall green prairie grass billowed and swayed in the gentle May breeze. Pierce Downer knew he had reached the end of his long journey from New York State when he saw an oak grove rising majestically from the prairie which "looked from the distance like an island, and the prairie around it like an ocean surrounding it." The year was 1832. The timing of Downers arrival on the Illinois prairie did not seem promising for two reasons: the outbreak of the Blackhawk War and the hazard of cholera which ran rampant through General Scott's troops. As it turned out, Downer not only had no hostile encounters with the Indians, but received friendly hospitality from both Chief Shabbona and Chief Waubonsee and the Potawatomis. He camped at the junction of two Indian trails, and perhaps Chief Waubonsee camped there with him some times. Whether he did or not, this place was one of Waubonsee's favorite campgrounds, and Waubonsee came there often.

Pierce Downer built a log cabin on the site where his subsequent house was built in 1842, which is still standing. For over two years Downer lived alone in the wilderness until he was joined by his 22-year-old daughter, young Adeline Downer.

Pierce Downer was the first settler in the grove that was to become Downers Grove, but he was soon joined by other settlers who were also seeking a better life. The news had spread back East about the unbelievable opportunities to settle and buy good farmland from the government. The way had become clear with the building of the Erie Canal in 1825, which opened the water route through the Great Lakes to northern Illinois.

On June 23rd, 1835, Dexter Stanley, his wife, Nancy, and their nine children arrived in Downers Grove where they found only three log cabins and a population of four. The family spent the summer of 1835 through the winter of 1836 in a rude log cabin on Maple Avenue. Dexter bought a large acreage, which is now the four corners of Belmont Road and Fifty-fifth Street and built a log cabin. In 1835, Edwin Bush arrived, claiming 122 acres and some three years later he married young Nancy Stanley.

Several members of the Peet family had come to the lower East DuPage River in the early 1830s, and later moved to the Downers Grove area. In 1835, Eunice Peet married Daniel Narramore, who had arrived in the Grove in 1835. Her sister Lucy married John Adams Richards and their first son was born here in 1836.

The year of 1836 was a favored one for the settlers in Downers Grove. Israel Blodgett and his wife Avis Dodge Blodgett bought a claim on the old Galesburg road, which later became Maple Avenue. Blodgett built a log cabin and a blacksmith shop where the present day Blodgett House stands. Though Blodgett was a new settler to this Grove, he was a veteran pioneer of the Illinois prairie, having come to Lisle Township in 1830. Horace Dodge, the brother of Avis Blodgett, and his family arrived in 1836 and Rev. Eliphalet Strong and his wife, a sister of Horace and Avis, had also come from the East that year.

Horace Aldrich and his family came from Jefferson County, New York as a result of Pierce Downer's letters. Other settlers in 1836 included Samuel Curtiss and his sons Henry, Roswell, and Charles; Jonas Russsell Adams, a first cousin of John Quincy Adams; also Walter Blanchard, Robert Dixon, Henry Puffer, Alexander French Foster, Levi Aldrich, and Asa and Silas Carpenter.

One of the first concerns for these pioneers was to provide schooling for their children. Both Israel Blodgett and Dexter Stanley built lean-tos onto their log cabins for schoolrooms and the daughters of these two men were the teachers. Likewise church was extremely important and the religious

services in the neighborhood were held in the home of Horace Dodge. Methodist circuit riders Rev. Stephen Beggs and Rev. Gaddis often preached here.

In 1836, there were four taverns in the area that was to become Downers Grove Township. Thomas Andrus opened a tavern in his home in Cass, Samuel Curtiss kept a tavern on Maple Avenue, Levi Aldrich had a tavern in what is now Memorial Park, and Howard Aldrich built a tavern on Ogden Avenue.

Henry Carpenter opened the first store in Downers Grove in 1845. Carpenter thought he could earn a better living as a storekeeper than trying to be a farmer. It was a good decision, since he had been a very poor farmer.

The settlement continued to grow with the many people who were migrating from New England and New York State. The families of the Grove became more and more intertwined as the young people grew to adulthood and marriages united the families.

Lucy Narramore Stanley wrote, "We were all neighbors . . . when sickness and sorrow came to one, all were ready to lend a helping hand. In those years of companionship we seemed like one family."

OAK GROVE. The occasional groves of trees rising from the prairie were sought by the pioneers who found comfort in their shade from summer sun, and in the cold of winter, protection from the winds sweeping across the open prairies. The settlers also needed the wood for their cabins and for fencing their land.

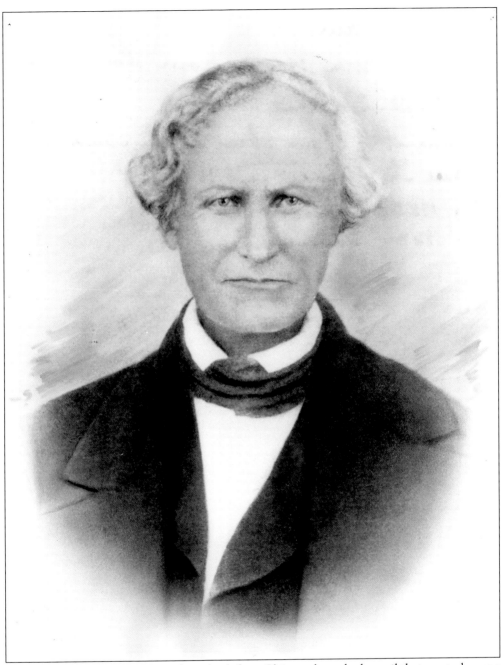

**Pierce Downer.** Setting out on horseback from Chicago, he rode the trail that was to become Ogden Avenue, until he saw the oak grove. The location was ideal. The high ground of the grove, with its abundant supply of lumber for fences and buildings was surrounded by rich prairie land. Pierce Downer was the first settler in Downers Grove.

**THE PRAIRIE.** One early settler wrote to his wife that the first view of an Illinois prairie is sublime . . . awfully grand, a person needs a compass to keep his course. The dense prairies of Illinois spread for miles on end, broken only by a few groves of trees. The thick root structure of the prairie was almost impossible to cultivate, and the first step for these pioneers was to pasture their animals on the grasses, and then try to break down the earth for their crops.

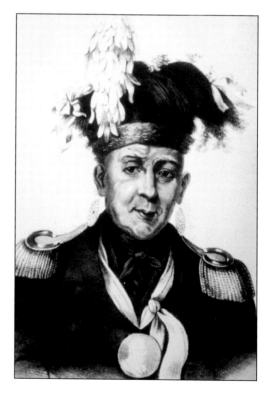

**WAUBONSEE.** Chief Waubonsee of the Potawatomies was friendly with Pierce Downer and undoubtedly warned him about the hostile Sauks. It is said that the Potawatomies patrolled the countryside on a regular basis to protect the white settlers.

**BLACKHAWK.** Blackhawk was the Indian Chief of the Sauk tribe, which led the Indian uprising in 1832 that was to be known as the Blackhawk War.

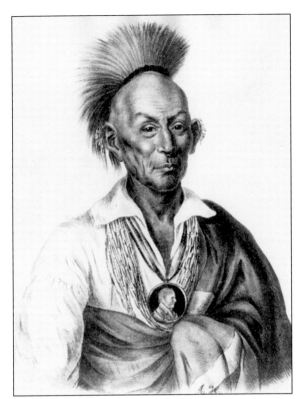

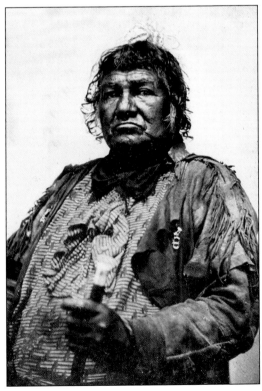

**SHABBONA.** Chief Shabbona and Chief Waubonsee along with 90 or so other Potawatomies not only rejected the war of the hostile Sauks, but banded together in warning the settlers.

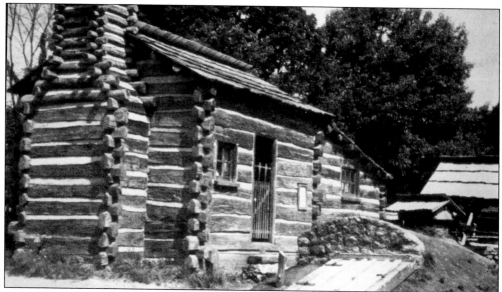

**LOG CABIN.** The new settler claimed his land by marking the boundaries, sometimes by a bent sapling or a pile of rocks, and then his next task was to build a log cabin for the shelter of his family. The designation of property lines was imprecise and there were a number of disputes over property ownership. One such dispute occurred between two friends, Horace Aldrich and Pierce Downer. Aldrich had come to Illinois as a result of Downer's letters, and Downer actually selected the land where Aldrich settled. Strangely enough they soon had a dispute over one particular section of land. In a hearing before the Land Office in Chicago, the land was awarded to Aldrich. Even stranger, there were no hard feelings and they remained close friends for many years after that.

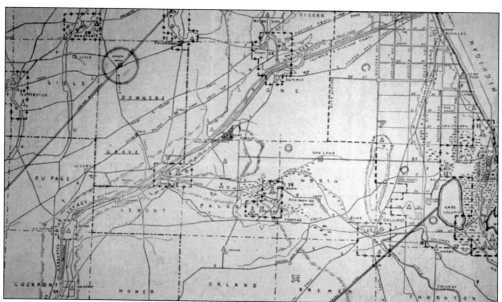

**INDIAN BOUNDARY.** This map shows the 10-mile corridor of safe transport for both white settlers and Indians from the Illinois River to Lake Michigan. The northern boundary goes through Downers Grove.

14

**ADELINE DOWNER.** For over two years Pierce Downer lived in his log cabin in solitude, as he carved a farm out of the wilderness. He was finally joined in October of 1834 by his 22-year-old daughter Adeline, who came to keep house for her father. Adeline was the first white woman in Downers Grove. That same year, Gary Smith also settled in the Grove. The young people met, fell in love and later were married. Gary Smith made a claim and built the first frame house in the grove for his bride. This house stood for many years on the northeast corner of Carpenter and Maple Avenue.

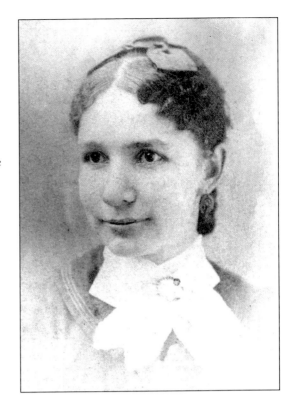

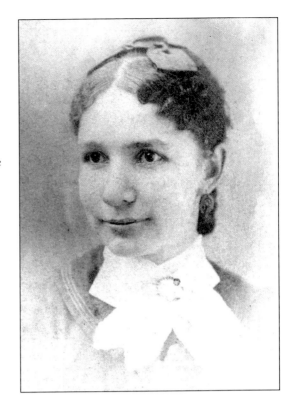

**PREEMPTION CERTIFICATE.** This is the certificate which transferred ownership—of the 160 acres Pierce Downer had settled as a land grant settler—from the United States of America to Pierce Downer for $1.25 an acre.

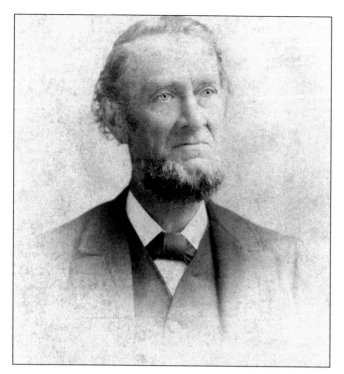

**JOHN STANLEY.** John Stanley was one of the nine children of Dexter and Nancy Stanley, who came to the Grove with his parents on June 23, 1835. They had traveled from Milford, Pennsylvania in covered wagons drawn by three teams. The Stanley family was the first complete family to come to the Grove.

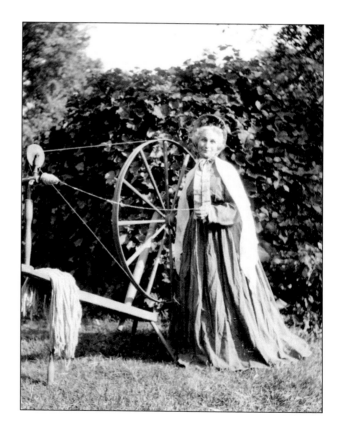

**OLD SPINNING WHEEL.** This picture shows Mrs. Susan Faul Foster, a descendant of Downers Grove pioneers, standing by an old spinning wheel that came to Illinois in 1842.

**TWO YOUNG LADIES.** The young lady in the top right picture is probably Nancy Stanley Bush, the daughter of Dexter and Nancy Stanley, the earliest family in Downers Grove. Nancy was the first teacher in the lean-to, which her father built for a schoolroom. Later she married Edwin Bush, who had arrived in the Grove in 1835. The other young lady is likely also a Stanley daughter. (Photos from the Bush family collection.)

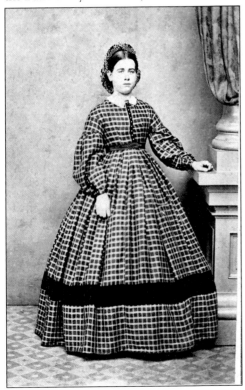

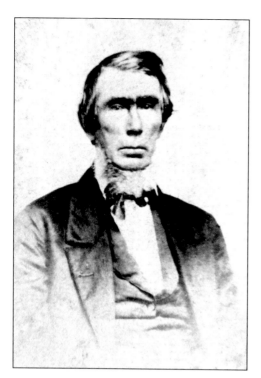

**ISRAEL BLODGETT.** Blodgett came to the Grove with his wife Avis and their six children in 1836. Their two younger sons were born later in the log cabin that he built on what is now Maple Avenue. He also built a blacksmith shop where he shod horses, repaired and built farm tools, and repaired guns. In this shop, he developed a self scouring plow which was invaluable to the farmers in cultivating the thickly rooted prairie ground.

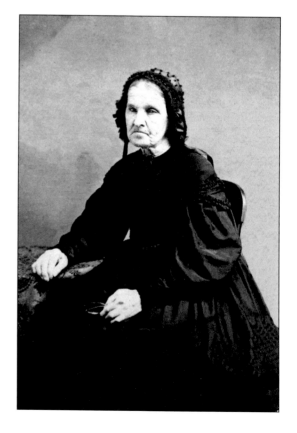

**AVIS BLODGETT.** Avis, the wife of Israel Blodgett, was a hardy pioneer woman who extended her hospitality not only to her relatives and neighbors but also to Indians and escaping slaves. Her son said that there was always a welcoming candle in the window. Avis and Israel were strong abolitionists and their home was an active station on the Underground Railroad.

**MARY BLODGETT.** Israel Blodgett built a lean-to onto his log cabin for a schoolroom and his daughter Mary was the teacher, for though she was only 12 years old. she was able to read. This picture has long been thought to be of that Mary Blodgett. Recently, however, there has been some evidence that it could be a picture of another Mary Blodgett, the wife of Aziel Blodgett, one of Israel and Avis Blodgett's seven sons.

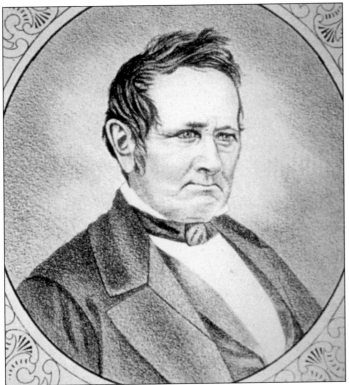

**SAMUEL CURTISS.** This early settler and his family, including his three sons, Henry, Roswell, and Charles, arrived from Vermont in 1836. Curtiss bought land from Israel Blodgett for one thousand dollars cash, and built a tavern and stables for accommodating the farmers who were traveling to and from Chicago

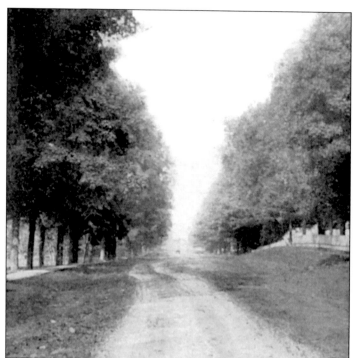

Maple Avenue Looking East. Israel Blodgett and Samuel Curtiss hitched oxen to a heavy oak log, which they dragged back and forth to make the roadway that became Maple Avenue. The original Indian trail went somewhat south, and Blodgett and Curtiss wanted the road to go between their properties, so that the farmers using the road would travel past Blodgett's blacksmith shop and Curtiss' tavern.

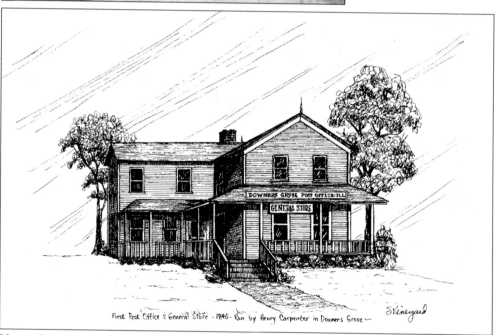

First Post Office & General Store - 1840 - Run by Henry Carpenter in Downers Grove —

Henry Carpenter House and Post Office. This house was built in the 1840s and was not only Carpenter's home and the post office, but also a general store. Carpenter stocked his store first with groceries, and then after a while he added a little clothing, hardware, boots, and shoes. However, he said, "Customers ran sparse, money scarce." Most of his sales were on credit. It was said that anyone smart enough to tie his shoes could get credit at Carpenter's store. This house still stands at the corner of Maple and Lane Place. (Drawing by Sue Vineyard.)

# Two

# EARLY SETTLERS
# 1850–1890

The community grew steadily as new settlers, eager to obtain land on the fertile prairies, continued to arrive from the East. Two good roads led to Downers Grove, the Southwest Highway (Ogden Avenue), which in 1851 was a plank road, and the other, Maple Avenue, which had been laid out by Curtiss and Blodgett. Log cabins were being replaced with more comfortable clapboard houses like the frame house Blodgett had built in 1849. In 1853, Samuel Curtiss built his new frame house. It was said that he had to build this house earlier than he had planned, because his log house had burned to the ground.

A.J. Foster lived in a house west of the plot of land where the Methodist church was later built, and the Belden blacksmith shop was just west of Foster's house. Henry Carpenter built his house in the early 1840s. The few houses were beginning to center around Maple Avenue south of the center of present day Downers Grove. At that time there were three established Protestant congregations in the Grove; the Methodists, the Congregationalists, and the Baptists, and all three built meeting houses.

The feelings of community grew and the need to band together for their mutual interests of property rights, containing livestock, and construction of roads arose. Therefore, on April 2, 1850 the first township meeting was held in Downers Grove. In 1851, the population of Downers Grove Township was shown as 957 people.

The small community continued to grow with settlers from New England, New York, and Pennsylvania along with the immigrants who were fleeing the tyrannies in Europe. Some of the most loyal and steadfast of the citizens of Downers Grove came from Alsace-Lorraine.

There was another migration coming from the south and west, not with a goal of settling, but running for their lives and freedom. These travelers were fugitive slaves fleeing on the Underground Railroad in search of safe refuge in Canada. There was a strong anti-slavery sentiment among the citizens of Downers Grove and the homes of these men and women formed a vital link in the Underground Railroad escape route.

In 1854, the new Republican Party was founded in Ripon, Wisconsin, and in Downers Grove an enthusiastic group of young men formed a political organization known as the "Plowboys" under the leadership of Captain T.S. Rogers. In the presidential election of 1856 the Plowboys campaigned for Fremont who lost to Buchanan, but they gloried in the success when they campaigned for Abraham Lincoln in 1860. All too soon, the Plowboys were called upon to serve their country in preserving the Union. In 1860, the township had a total population of 1,806 and over ten years later the Village of Downers Grove had a scant 350 inhabitants. It is difficult to comprehend that this small community sent 119 men to the Union Army. Not a family was left untouched as the men marched off to war.

If one were to name the single most important influence in the development of the Village of Downers Grove, it would have to be the coming of the railroad. Surprisingly, the advent of the railroad was in 1863 in the middle of the Civil War. Given the high cost of materials and the shortage of labor due to the Civil War, it is almost unbelievable. The CB&Q Railroad Company made the decision on February 11, 1862 to construct the railroad from Aurora to Chicago through Downers Grove, and the first train came through Downers Grove on its way to Chicago in May of 1864.

With the coming of the railroad, it was obvious that Downers Grove needed a railroad station and there were many other changes in the Village as well. Samuel Curtiss opened the first subdivision in the present business section of Downers Grove. The soldiers were astonished at the changes in the Village when they returned from the war. When they had left there was no railroad and Maple Avenue was the only street for through horse traffic in town. And now, with the coming of the railroad, Main Street had been cut through from Maple Avenue to the tracks, and there were other new streets as well.

The Great Chicago Fire of 1871 cast a pall on the Villagers of Downers Grove. Many of the Downers Grove residents had businesses in Chicago, which were destroyed. Many had friends and family in

Chicago who were burned out. The shock of the great devastation and the tragedies of the residents of Chicago were felt throughout the area. The citizens of the Grove immediately rallied to send help to those in need.

In 1873, with a population of a little over 350, some of the residents felt there should be a Village Government. They drew up a petition, held an election, and with a majority of 11 votes Downers Grove was incorporated, and Captain T.S. Rogers was elected Village president. The Village was described in 1874 as having 90 dwelling houses, some of which were very good, three general stores, a meat market, a coal and lumber yard, a drugstore, a two-story brick school house, a fine hotel, and four organized churches. The activities of the citizens of the Village centered around the churches, school, and a few social groups. With the railroad depot and the stores, the Village became a gathering place. Each evening as dusk fell, the lamplighter would come along with his little ladder in hand. He would place the ladder against the lamppost, fill the street lamp with kerosene and light it and then go on to the next light. The Village had become very modern with its wooden sidewalks and kerosene street lamps.

Downers Grove prospered with the increasing value of land, the fine transportation into and out of Chicago afforded by the CB&Q, and the modern progress of the facilities of the Village. Soon, the real estate developers arrived. Gen. A.C. Ducat settled in Downers Grove and bought some 800 acres of land. Marshall Field, a friend of A.C. Ducat, also bought a large acreage in Downers Grove and E.H. Prince laid out his subdivision.

The villagers loved parades and celebrations and they all turned out to watch the Plowboys! A generation after the original Plowboys, their sons organized to campaign for Benjamin Harrison in the presidential campaign of 1888. The Plowboys of Downers Grove went clattering down the street in their huge wagon with their new silken banner flying proudly from the tall mast, as they cheered for Harrison!

**PLANK ROAD.** This photo shows huge wagons rolling along on the plank road. By 1851, the Southwestern Road (Ogden Avenue) was completed as a plank road from Chicago to Naperville with tollgates every 5 to 6 miles. The planks were placed firmly on a hard roadbed and the road was expected to remain in good condition for years. However, with the problem of water under the planks, and heavy wheels dislodging the planks, in only a few years the plank road was in a deplorable state. (Photo from Kalamazoo Historic Museum.)

**JUDGE WALTER BLANCHARD.** Walter Blanchard and his family arrived in Downers Grove from New York State in 1836 and bought a farm of 200 acres. Blanchard had been a Probate Judge in DuPage County for seven years when he resigned to enter the Union Army. Judge Blanchard was 54 years old when he volunteered and was commissioned a Captain. He raised a company for the 13th Illinois Volunteer Infantry, one of Illinois's first regiments. Captain Blanchard was mortally wounded at Ringgold Gap. It is said that his last command, given after he fell, was "Don't give up boys! Fire away!"

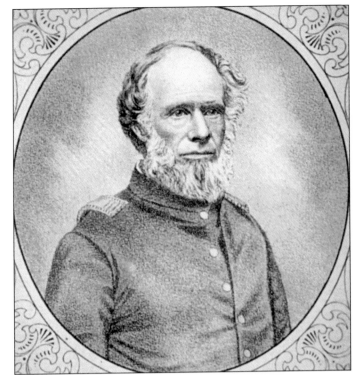

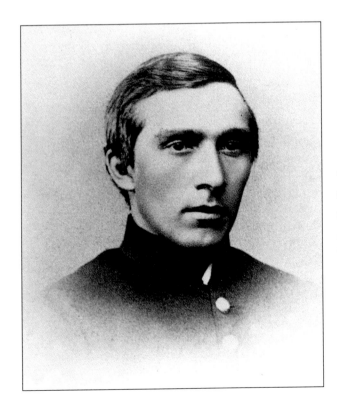

**WELLS BLODGETT.** When the second call for troops came in July 1861, Wells Blodgett, a First Lieutenant, enlisted a company of 40 men and was assigned to Company D, 37th Regiment, Illinois Volunteers, which camped in Wright's Grove on North Clark Street. When they were ordered to move to the front on September 1, 1861, Edward Blodgett, Wells' brother, also enlisted and marched away with them. Wells was subsequently awarded the Congressional Medal of Honor.

**Captain T.S. Rogers.** After President Lincoln's call in 1862 for 300,000 more men, Sheriff T.S. Rogers volunteered, and received a commission as Captain with the authority to recruit one company of 100 men. T.S. Rogers was one of the early pioneers of the Grove and later served as its president for 14 years. By August 6th, 138 men had enlisted in his company, which had only one hundred openings. There were still so many other men who wanted to serve that in less than 30 days, four full companies were recruited in DuPage County.

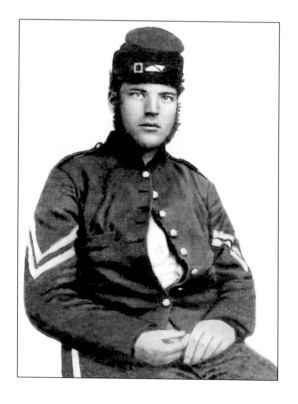

**CPL James Moses Barr.** In September of 1861, James Barr wrote his cousin, Warren Rogers, "Everybody talks of war, thinks of war, dreams of war or goes to war—and I think we will all have to go before it is ended." On January 9, 1862, James Barr fulfilled his own prophecy by joining the Illinois Volunteer Infantry, 33rd Regiment Company B. The 33rd Infantry was a three year regiment that saw hard service.

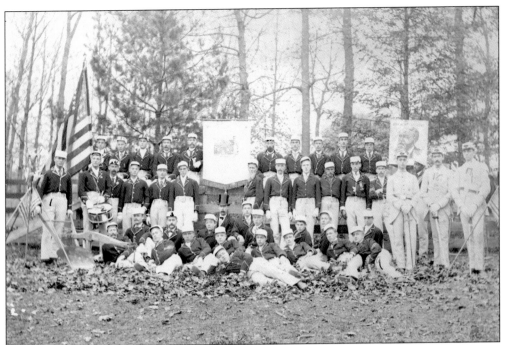

**PLOWBOYS.** A generation after the organization of the original Plowboys, their sons, under the direction of Capt. William Blanchard, organized the "Sons of the Plowboys" to campaign for Benjamin Harrison in the presidential campaign of 1888. Just as their fathers had campaigned in the villages up and down the CB&Q and even into Chicago for the new Republican Party in 1856 and again in 1860 for the election of Abe Lincoln, the new Plowboy group campaigned for the Republican Party in 1888.

**PLOWBOY BANNER.** Miss Mabel Stanley, representing the young ladies of the Grove, presented a banner to this new Republican Plowboys Club at a.meeting on September 21, 1888. Mrs. H.D. Foster had done most of the work on this "most beautiful silk banner, on one side of which was painted a unique log cabin and the name of the club and on the other side a large and handsome spray of cereals and flowers with the inscription Protection to Home Industries, worked in gold." The banner is now in the Americana Collection at the Smithsonian Institution.

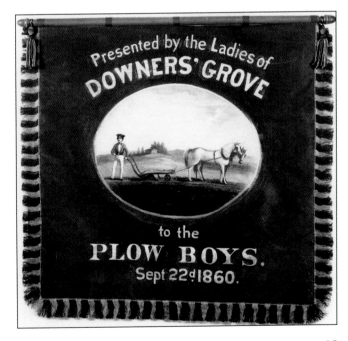

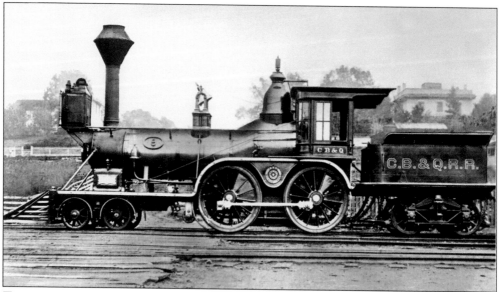

**TRAIN FROM AURORA TO CHICAGO.** This photograph was taken in 1865 of one of the early trains traveling through Downers Grove on its way from Aurora to Chicago. The CB&Q Railroad Company formally authorized the construction of the railroad line from Aurora to Chicago through Downers Grove on February 11, 1862. The work of building the track was begun that year. After encountering great difficulties in the construction of the railroad tracks, the roadway was finally completed from Chicago to Aurora. In May of 1864, the first passenger train on the new CB&Q line pulled into Downers Grove from the west. It continued east through East Grove (Fairview), Greggs Station (Westmont), and on through the other villages to Chicago.

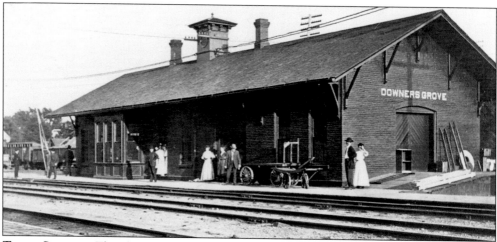

**TRAIN STATION.** This shows the first train station in Downers Grove. It was built in 1865 on Main Street. With the CB&Q railroad line coming through Downers Grove it was obvious that the Village needed a railroad station. Some thought it should be at Belmont Road, influenced by the offer of donated land for the station. The committee, however, charged with the responsibility of making the selection, decided that the best location would be at present Main Street. Mr. John Coates, the owner of the land, had no interest in donating his land, and obstinately held to his price of $500. The committee considered its options, made the decision, raised the $500 and purchased the land for the depot.

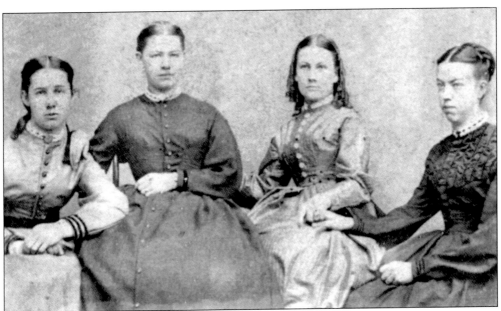

**NAPERVILLE ACADEMY GRADUATES.** Pictured are the four young ladies who were graduates of the Naperville Academy in the early 1860s. From left to right are Laura Blodgett, Elizabeth Oldfield (later Mrs. George Heartt), Hannah Ditzler (later Mrs. John Alspaugh), and Elizabeth Norton (Mrs. Sylvester Ballou).

**J. WARREN ROGERS BUILDING.** This shows the J. Warren Rogers building on the east side of Main Street, north of Railroad Street (now Burlington), where the Village election of 1873 was held. In the early 1870s, the Village had a population of about 350, and many of the residents felt the time had come to incorporate. There were others who did not support incorporation because of their concern about increased taxes and the regulations of a new city. In 1873, those residents who were for incorporation drew up and signed a petition, which they presented to the Court of DuPage County. As a result of the petition the court issued an order that an election be held at the office of Warren Rogers on March 29, 1873. The election was hotly contested for weeks, and there was little doubt that virtually every voter who was eligible to vote, voted! The result was 49 votes for incorporation and 38 votes opposed. Downers Grove was incorporated as a village as a result of a majority of 11 votes!

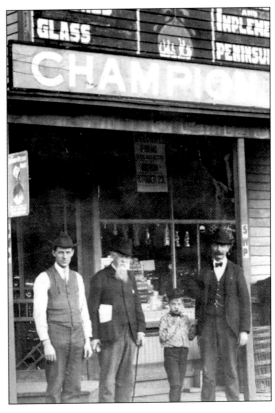

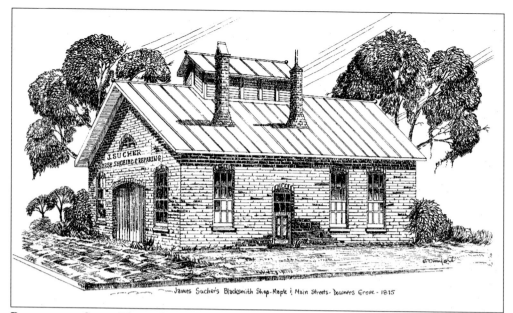

**BLACKSMITH SHOP.** This is James Sucher's blacksmith shop at Maple and Main as shown in this drawing by Wes Vineyard. Sucher, a skilled blacksmith, had been a fifer in the Civil War, and it was said that anytime a child asked him to play a tune, he would lay aside his hammer and reach for his fife. (Picture by Wes Vineyard.)

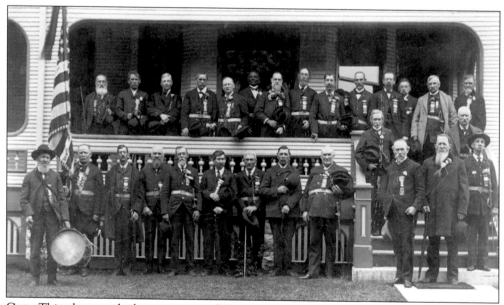

**GAR.** This photograph shows a group of Downers Grove Civil War Veterans. The sixth man from the left on the upper level is Israel Blackburn, a freed slave, who settled in the Grove after the war. Blackburn served in the 124th Infantry Regiment of the US Colored Troops, Company C. He moved to Downers Grove in 1866, when he was befriended by Sam Curtiss who sold him 3.5 acres, where the present-day Christian Science Church is located on Curtiss Avenue. He raised and sold vegetables from his garden and also engaged in teaming. Israel Blackburn was one of the signers of the petition for the incorporation of Downers Grove in 1873.

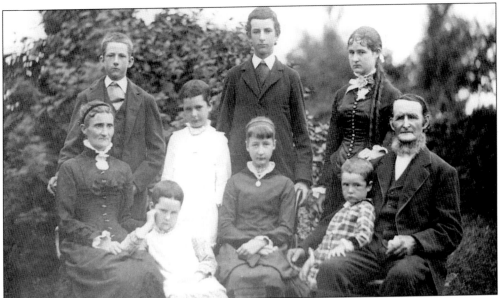

**BENJAMIN PRENTISS FAMILY.** The Prentiss family had a farm on the southwest section of the Village, along present day Sixty-third Street. In the early morning of the 8th of October in 1871 Benjamin Prentiss and his wife were awakened by a glowing light in the sky. They realized at once that the bright sky in the east could only be an enormous fire in Chicago! At dawn he started in his wagon for Chicago to take food and supplies to the people in Chicago who were burned out of their homes. This picture of the Prentiss family was taken in the early 1880s. Seated in the front row, from left to right, are Regina Prentiss with her daughter Ruth leaning on her, Florence, Charles, the youngest of the family, and Benjamin Prentiss. In the back row are Ben, Effie (in the white dress), Frank, and Sabra. Picture taking was a very serious undertaking in those days, "Don't move and don't smile, for smiles are hard to hold!"

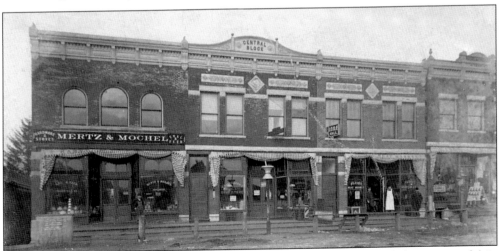

**MERTZ & MOCHEL HARDWARE.** Charles Mochel and Levi Mertz opened this store on Main Street on June 25, 1884 in the same location where Mochel's Hardware continued to do business for over 100 years. Merchandise ordered from traveling salesmen was delivered by railroad freight. Mertz and Mochel rented a right of way and spur tracks from the railroad for $30 per year. This was just west of Forest and south of the present-day tracks. (Photo from John Mochel Jr.)

**CHARLES MOCHEL.** This picture of Charles Mochel was taken in 1880. Levi Mertz and Charley Mochel built the building and opened the hardware store in 1884. Several times a year, Mochel would make a three- or four-day trip to Chicago to buy merchandise and haul it back on his wagon. Mertz and Mochel were in business together until 1922 when they dissolved their partnership of 38 years, and Mochel formed a partnership with his son, John Sr. Charles Mochel played a vital part in the growth of this village. He served as president of the Village for two terms, and was very influential in the progress of the Village. (Photo from John Mochel Jr.)

**MOCHEL'S FIRST DELIVERY WAGON.** This was Mertz and Mochel's first delivery wagon in the cold winter of 1890. Feed, salt, nails, and fencing were delivered by the carload to the spur at the railroad and transferred to the store. Coal was also unloaded here, piled on the ground, or put in open sheds, 40 or more tons at a time—by hand. The coal was shoveled on to this delivery wagon, brought to the scale at the store, weighed, and delivered to the customers. (Photo from John Mochel Jr.)

30

**GENERAL A.C. DUCAT.** A Civil War veteran, General Ducat settled in Downers Grove and invested in real estate. In 1885, he owned some 800 acres which were described as "splendid grove land, whose picturesque loveliness is not surpassed anywhere on this continent." General Ducat subdivided land south of Fifty-fifth Street and east of Main Street. He wanted to make a model town of Downers Grove and, in 1885, offered to put in a water system if the Village Board of Trustees would remove the front yard fences. The Village Board declined his offer.

**MARSHALL FIELD.** Field also invested in many acres of real estate in Downers Grove. He owned the land, which he sold to the Village for the first water tower, as well as the land which was developed into Denburn Woods. It is said that he sold a large parcel of land to the Forest Preserve. Though he didn't live in the Grove, he was here regularly as a golfer at the Downers Grove Golf Course. (Photo from the Chicago Historical Society.)

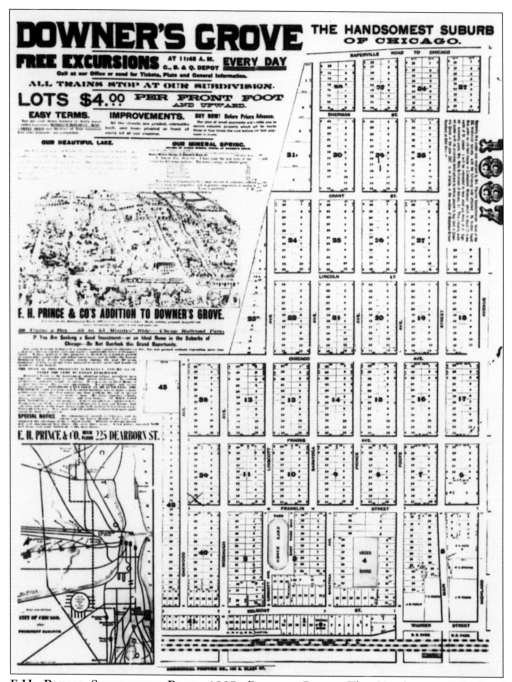

**E.H. Prince Subdivision Plat—1887.** Downers Grove—The Handsomest Suburb of Chicago. "No codfish aristocracy, criminals, toughs, or saloons."

# Three

# THE MARCH OF PROGRESS
# 1890–1929

The year of 1890 was a notable time of growth for Downers Grove. The Village counted a population of 960 people, and day by day new families were moving into the community. This was also the year that Casper Dicke moved his machine shop here to become the first industry in the Village. Dicke's shop manufactured tools for electrical linemen of such superior quality that he received a grand prize for his products at the Paris World's Fair.

The price for the progress of the Village came high when there was a clash of conflicting interests. E.H. Prince platted a subdivision north of the tracks covering 225 acres of land. It then became important to have a Main Street, which would go straight through town. The problem came when the Main Street right of way would need to go through the farm of Capt. T.S. Rogers. Even worse, the home of his mother was directly in the path of the proposed roadway! When Rogers and Prince were unable to reach an agreement for the price of the property, arbitrators were named who awarded a price less than the original offer. The house was moved to 4942 Saratoga, and Main Street was opened to the Plank Road and was named Rogers Street. Highland Avenue was cut through at the same time and called Main Street.

It was an exciting development in the community in 1893 when A. Haddow Smith laid out and opened a 9-hole golf course on 60 acres of land, which he owned at Belmont near the CB&Q. This was the first 9-hole golf course west of the Appalachians.

A booklet in 1895 sang the praises of Downers Grove, boasting that among all the other advantages to living in Downers Grove was the fact that this village had direct telephone communications with the city. This consisted of one telephone in Carpenter's Drug Store on Main Street. However, only a couple of years later, telephones were available in some 20 homes. The booklet continued with the information that saloons were prohibited, but there were stores of nearly every character. The travel time to Chicago on the Burlington was 43 minutes and there were 25 trains each day.

Toward the end of the 19th century, the nation's immigration pattern changed from the migrations of Western Europe to the migrating Polish, Hungarians, Czechs, Slovaks, Croats, and Russians. Downers Grove's population reflected this change. A real estate developer, said to be Polish, laid out a subdivision in East Grove, which was known as Gostyn. Many of the settlers there were from a community in Poland named Gostyn.

By 1900, the population of the Village was over 2,000. The changes in the Village in the ten year period from 1890 to 1900 were incredible with the Village Waterworks, the electric plant, the telephone system, an organized fire department, and many charming new homes.

With the beginnings of the 20th century the Village prospered with stores and businesses to serve the residents and neighboring farm folks. Brick streets were laid, and sewers were built. A second bank, the First National Bank, joined the Farmers' and Merchants' Bank in 1910. A new fine brick passenger railroad station was built in 1912 after years of planning. A group of ladies formed a Library Association which had met in an upper room at the Farmer's and Merchants' Bank building, and then in 1915 the new library building was built at the corner of Curtiss Street and Forest Avenue. And movies came to town in the Dicke Theatre and in the new Paragon Theatre, which later became the Curtiss theatre.

As the Village continued to grow it became evident that a more efficient form of government would be in order. So the citizens of Downers Grove went to the polls and voted to change to a commission form of government. This changed the governing board to a mayor and four commissioners and the first election for these officials took place on May 1, 1917.

These were extraordinary times of progress, and then it all changed with the entry of the United States in the War in Europe. Sadly, the villagers of Downers Grove sent their boys off to war. Eight

of these young men died in action.

In 1919, there was a massive celebration honoring the returning servicemen at the courthouse in Wheaton. And in 1925, a bronze plaque, listing the names of the many men who had served in World War I, was placed on the new Memorial Village Hall, which was built on Main Street.

With the return of these men and boys, the Grove returned to the good times again and continued to grow. The splendid new high school was built in 1928. The new Masonic Temple was built at the corner of Washington and Curtiss Streets. A fine business building was built at the corner of Main and Railroad Streets (later Burlington), which housed 6 stores and had 14 offices on the second floor. Then, in 1928, the impressive Tivoli Hotel and Theatre building was built at the corner of Highland and Warren. The Tivoli was the second theatre in the United States to be designed and built for talking movies.

Many new homes were built and many of them were self-assembled, mail-order homes bought from a number of companies. The most successful of these companies was Sears Roebuck and Company. Between 1908 and 1940, Sears listed in its catalog some 450 models of homes in kits to be assembled by the buyer. These homes were so attractive and such a good value that prospective homeowners were immediately drawn to the possibility of having a fine new home at a modest price. The railroad made the purchase of these home kits a possibility for the citizens who wanted to build in Downers Grove. The house kit of some 30,000 to 40,000 pieces would be shipped in a railroad car, and because of the switching roundhouse and railroad sidings in Downers Grove, there was track room for the car to remain for some seven to ten days as it was being unloaded. The new owner then could follow the meticulous instructions to build his house himself, or he could have a contractor complete the house. Downers Grove is among the towns that have the largest collections of Sears' homes largely because of our rail siding accessibility.

The 1920s brought heady times of growth and accomplishments. With the passing of the 19th amendment, which gave women the right to vote, Downers Grove sent the first woman to the Illinois General Assembly in 1922, Lottie Holman O'Neill. That same year the opening of King Tutankamen's tomb in Egypt brought international fame to Dr. James Henry Breasted, who had grown up in the Village.

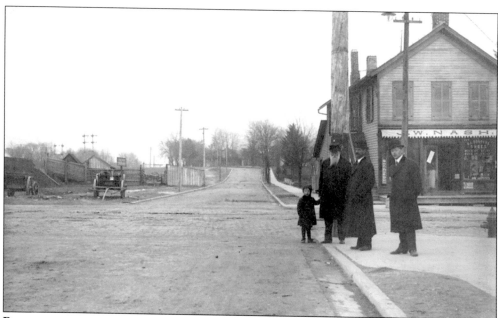

**Burlington and Main.** This photo shows the corner of present-day Burlington and Main about 1900. The open area in the picture was a holding area for animals waiting to be shipped to Chicago. It was a sorry day in the summertime if the wind came from the east when the pen was filled with livestock. On the street corner, from left to right, are an unidentified child, Jake Miller, J.L. Lozier, and J.W. Hughes.

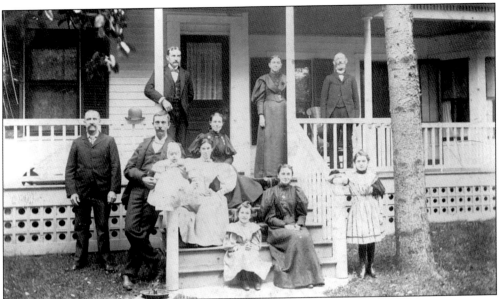

**CHARLES CURTISS AND FAMILY.** This Curtiss home was the gathering place for this picture in about 1897 or 1898. At the bottom, Laura Caldwell is sitting on the lowest step—the next row, from left to right, are Mrs. Samuel Curtiss II, Mrs. Addie Curtiss Caldwell, and standing beside her by the tree is Irene Caldwell. The next row up are Charles Caldwell, Samuel Curtiss II holding Ted Curtiss, and Alice Curtiss Heckman sitting at the top of the steps. Standing on the porch are Alfred Heckman, Mrs. Charles Curtiss, and Charles Curtiss.

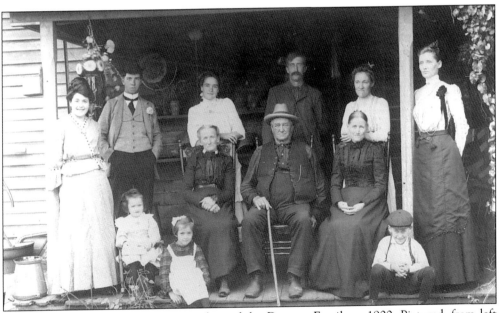

**DOWNER FAMILY.** This picture was taken of the Downer Family c. 1900. Pictured, from left to right, are two unidentified children and the young boy on the right is Earl Downer. The seated group, from left to right, includes Ellen Knox Downer, Elon Downer, and unidentified. Standing from left to right are two unidentified people, Lucy Lindley Eickhorst, unidentified, Nellie Archer Downer, and unidentified.

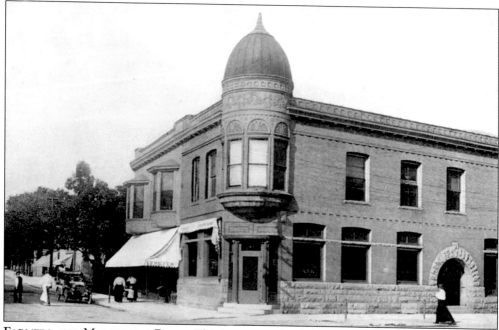

**FARMERS AND MERCHANTS BANK.** This impressive bank building was built on the northeast corner of Main and Curtiss in 1892. The building still stands, though considerably remodeled. The first library in the Village started here in the space donated by the bank, and for a number of years the post office was housed here.

NUMBER TWO.

# FARMERS AND MERCHANTS BANK.

## DOWNERS GROVE, ILL.

Quarterly Statement, October 26, '92.　　　　Organized May 10, 1892.

| RESOURCES. | | LIABILITIES. | |
|---|---|---|---|
| Loans and discounts........ | $61426.32 | Capital stock............... | $25000.00 |
| Cash ...................... | 5229.56 | Undivided profits........... | 1176.75 |
| Due from other banks....... | 16003.29 | Individual deposits subject | |
| Banking House............. | 5717.12 | to check................ | 50580.08 |
| Furniture and Fixtures..... | 785.24 | Demand certificates of deposit | 11756.49 |
| Current Expenses.......... | 334.54 | Due other banks............ | 982.75 |
| | $89496.07 | | $89496.07 |

Safety Boxes in Fire Proof Vaults in our New Building For Rent.
Deposits of Individuals, Merchants and Corporations, are Kindly Solicited.

CHAS. CURTISS, Pres.,
　　W. A. TOPE. M. D., Vice Pres.
　　　　W. H. EDWARDS, Cashier.

JAKE KLEIN, CONRAD BUSCHMAN,⎫
CHAS. MOCHEL, L. P. NARAMORE, ⎬Directors.
ALBERT SMART, T. T. THOMPSON.⎭

**THE BANK'S QUARTERLY STATEMENT.** The quarterly statement dated October 26, 1892 was printed on a postcard. The assets are shown as $89,496.07. The officers included Charles Curtiss, president; W.A. Tope, M.D., vice president; and W.H. Edwards, cashier. The directors were Jake Klein, Conrad Buschman, Charles Mochel, L.P. Narramore, Albert Smart, and T.T. Thompson. (Photo from John Mochel Jr.)

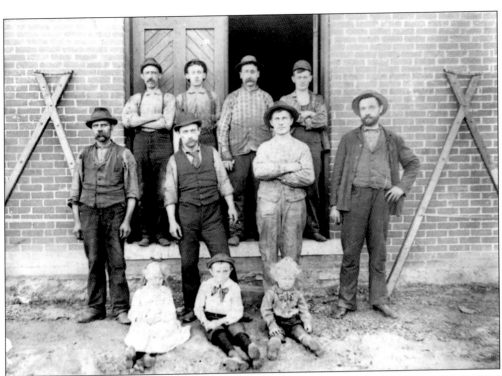

**DICKE TOOL COMPANY.** The employees of the Dicke Tool Company lined up to have their picture taken on this summer day in 1896. The Dicke Tool Company at 1201 Warren Avenue is the oldest industry in the Village. In the second row, far right, is Casper Dicke, the founder of the business. In the bottom row from left to right are Frieda, Henry, and Grant Dicke, children of Casper Dicke.

**CASPER DICKE.** Casper Dicke started his machine shop in Chicago in 1886 and moved it to Downers Grove three years later. Dicke was very influential in the progress of Downers Grove. He recognized the need for modernization: electricity, water works, and paved streets. One of his most important contributions was to the Downers Grove Fire Department, which has been closely associated with the Dicke Family.

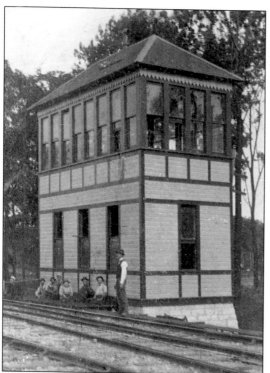

**WATCHTOWER.** The watchtower was built in 1893 and served the very important function in the routing of trains. It was in this tower that the watchman-telegrapher worked. He was responsible for receiving the telegraph messages which instructed him to set the signals for red or green for the trains. He also received and transmitted "the orders" to the engineers. The role of the watchman-telegrapher was critical to the operation of the trains before the use of electric semaphores.

**GUY BUSH AND FRIENDS.** Guy Bush is in the foreground of this picture, sitting on the ground in the front row, with friends on a social occasion. Guy Bush, a descendant of the Dexter Stanley family, served as president of the Village Board for two terms. Then, in 1898, he was elected a member of the State Legislature from the 41st district. He was returned to the Legislature and served for six successive two-year terms.

**JOHN MOCHEL SR.** This shows John Mochel Sr. in his University of Chicago Baseball Team uniform. Mochel and his teammate, Ted Curtiss, also from Downers Grove, traveled to Japan in 1920, as members of the winning University of Chicago Baseball Team, to play a number of Japanese teams. Quite a trip when you consider the transportation facilities in 1920. (Photo from John Mochel Jr.)

**CHILD'S PLAY.** Young Elmer Herrick holds the reins of the old horse, Buster, as he pumps water to give the horse a drink. His small brother Bartle Herrick is on the horse with Reverend Babcock's daughter. Elmer and Bartle were descendants of original pioneers to the Village, and their father William Herrick was secretary to the Board of Education for many years. Herrick Junior High School is named in his honor.

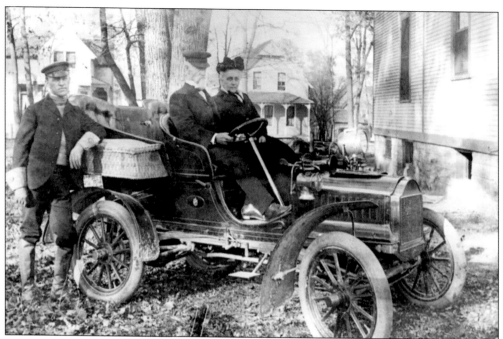

**WALTER BARBER AND HIS 1904 OLDSMOBILE.** Dr. Walter Barber is shown leaning on his 1904 Oldsmobile, which was the second car to be owned in the Village. Mr. George McDougall had bought the first automobile in Downers Grove in 1903. Dr. Barber's parents, Mr. and Mrs. William Barber, are seated in the front seat with Mr. Barber at the wheel.

**MADGE BARBER.** Mrs. Walter Barber became the first woman driver in the Village in 1910 when her husband taught her to drive.

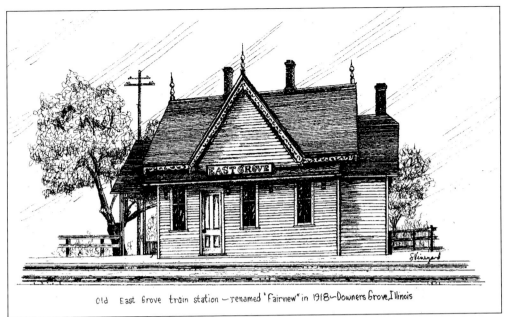

Old East Grove train station — renamed "Fairview" in 1918 — Downers Grove, Illinois

**EAST GROVE STATION.** This is an artist's rendering of the first station at Fairview Avenue. (Drawing from Sue Vineyard, the artist.)

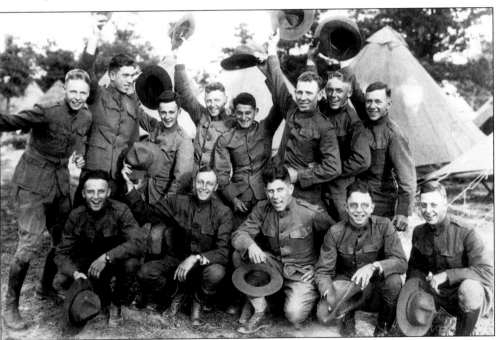

**BATTERY C 149TH F.A. ILLINOIS NATIONAL GUARD.** This picture was taken in 1917 at Fort Sheridan. This group was later a part of the Rainbow Division. From left to right, are: (front row) unidentified, Gilbert Lacey, Chet Hall, Myron Towsley, and Grant Nash; (top row) Alexander Bradley Burns, Fred Edwards, Stewart Burns, Sam Bertolin, Harry Grant, Fred Sachstedder, and Dwight Cox. Sadly, Alexander Bradley Burns, the laughing young man at the top left of the picture was killed in action. The American Legion Post is named in his honor.

**LOTTIE HOLMAN O'NEILL.** The passing of the 19th Amendment in the summer of 1920 gave women the right to vote, and a short two years later Lottie Holman O'Neill was the first woman in Illinois to be elected a Representative in the Illinois General Assembly. From her first election in 1922 O'Neill served continuously until her retirement in January of 1963, except for one two-year term. Lottie Holman O'Neill served 13 terms in the House of Representatives and was elected to the State Senate in 1950, 1954, and 1958.

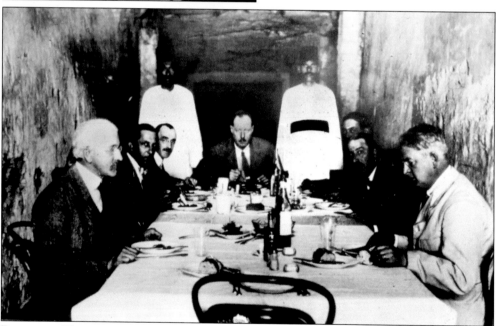

**DINNER IN TUTANKHAMEN'S TOMB.** Dr. James Henry Breasted, noted Egyptologist, at the left of the picture, is dining with the others who were present at the opening of King Tutankhamen's tomb. These men had viewed the magnificent treasures at the opening of King Tut's tomb in 1922. The myth was widely held that anyone entering a tomb was cursed. To dispel the myth this group of men had this dinner in a tomb adjacent to King Tutankhamen's tomb.

**SEARS HOME.** This shows the brick Sears Home at 5535 Dunham Road. This house was built by William Nielsen. The model is the Elmhurst and is presently owned by Stan and Amy Balicki. (Photo by M. Dunham.)

**SEARS HOME.** This home was built in about 1924 at the corner of Saratoga and Prairie in the E.H. Prince subdivision. This model is the Alhambra and is one of the larger of the kit homes. The present owners are Barbara and Stuart Martin. (Photo by M. Dunham.)

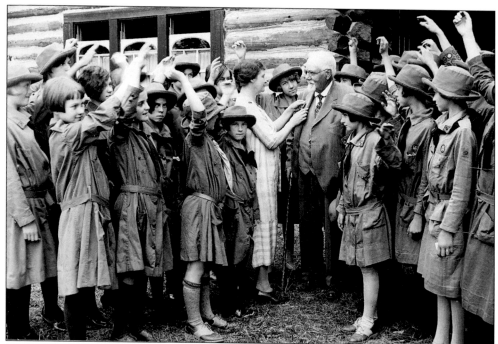

**DADDY WELLS AND THE GIRL SCOUTS.** John Manning Wells is shown surrounded by a large group of appreciative Downers Grove Girl Scouts in front of the Girl Scout Cabin built in the Forest Preserve just east of Memorial Park. "Daddy Wells," as he was fondly called by the Downers Grove Girl Scouts, was largely responsible for the girls having this cabin.

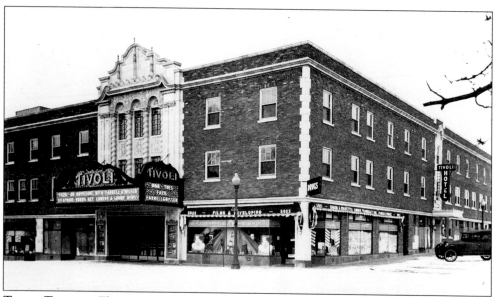

**TIVOLI THEATRE.** The magnificent Tivoli Hotel and Theatre building was built at the corner of Highland and Warren in 1928. The elegance of the Tivoli Theatre was beyond compare. The Tivoli was the second theatre in the United States to be designed and built for talking pictures. When the Tivoli Theatre opened at 1:30 P.M. Christmas Day, 1928, there were 4,000 people in line waiting to see a "talking movie." The Tivoli Theatre celebrated its 75th anniversary in 2003.

# Four

# THE DARK YEARS
# 1929–1947

Then came 1929 and everything changed. In October 1929, there were three banks in Downers Grove. On November 5, 1931 there were no banks in Downers Grove. Throughout the country, these years were filled with worry and despair. Many of the villagers were without jobs and money was scarce. The entire community worked together to try to find jobs for the jobless and provide food and coal to those in need.

Despite the hard times, the spring of 1932 brought an upbeat spirit to the Village, when the decision was made to have a celebration of the Village's first 100 years. The magnificent celebration was held on July 4, 1932 to the delight of all the people in town, the oldsters who remembered, the middle generation who needed a celebration, and the children who would never forget the joy of it.

Through the decade of the 1930s, farmers and businessmen had a grim struggle trying to keep their own businesses afloat, much less trying to help the jobless in the community. Nonetheless the villagers of Downers Grove did help their own. The Downers Grove Reporter of December 18, 1933 ran an editorial congratulating the citizens of Downers Grove for all their fine efforts in helping one another in these trying times.

Downers Grove also had other reasons for congratulations. Depressing times had not stemmed creativity. An outstanding best seller, *Oil for the Lamps of China*, was written by Alice (Nourse) Tisdale Hobart, who had grown up in Downers Grove. Her sister, Mary Nourse, was also a best selling author. Their brother Edwin, an economist, became president of the Brookings Institute in Washington D.C. Another author, Sterling North, who wrote *Rascal*, chose to live in Downers Grove, and his sister, Jessica North MacDonald, another well-known author and poet, also lived here. Lane Newberry, a famous artist, lived in the Village from 1933–1958. Another artist, Adolph Heinz, who lived on Main Street, exhibited his work at the Chicago Galleries on North Michigan Avenue. He was well known for his pictures of Glacier National Park. And the portrait of Dr. James Henry Breasted, who grew up in Downers Grove, was on the cover of Time magazine, which featured him as the outstanding Egyptologist and historian of the ancient world.

The year of 1933 brought a new vocabulary to the nation with the alphabet names of the many different recovery agencies. The Village benefited from these various federal work programs. Men were put to work, which brought money to the Village, and many projects were completed in Downers Grove.

The population of the Grove did not increase during the decade of the 1930s. The population in the census of 1930 was 8,977 and in the census of 1940 was 9,526—an increase of only 550 people in a ten-year period. Families combined households in order to survive. Very little real estate was sold, and because of the doubling up of families, there were many houses for rent.

Though the day-to-day living took courage and fortitude, the villagers of the Grove continued their activities in finding and enjoying the simple pleasures. Life in the Village was filled with the activities of the churches, lodges, clubs, school athletic events, plays, concerts, and lectures. One outstanding event in May of 1934 was the arrival of the Zephyr; the new streamlined CB&Q train streaked through Downers Grove on its world record run from Denver, Colorado to Chicago. Hundreds of Downers Grove residents lined the tracks to see the Zephyr come speeding through the Village at 85 miles an hour

With the cooperation of the community and the assistance of the federal government, Downers Grove made small gains through the decade. A new water tower was built with help from the federal government, and also the government made a PWA grant toward the building of a new gymnasium addition to the high school. Woolworth's built a new store on Main Street, which delighted the residents, and in September 1940, the Citizens National Bank opened its doors, after nearly nine years

without a bank in Downers Grove.

In 1940, the economy gradually improved as the country was gearing up for military production, but this was coupled with the adjustment of the unreality of young men going off in a peacetime draft. Then came the terrible shock of December 7, 1941.

The pain of this attack came suddenly and swiftly to Downers Grove with word that D.G. Marine Bernard A. Weier had lost his life on the USS Arizona in the attack at Pearl Harbor.

The next four years went by with sadness and complete dedication to the war effort, as the young men went off to war and their parents, wives, and sweethearts worked in war plants, tended war gardens, bought bonds, and gathered rubber, aluminum, steel, tin, and paper in scrap drives. The Red Cross manned a mobile blood unit and the citizens of the Village contributed again and again. The people on the home front learned to live with rationing their sugar, coffee, food, fuel oil, tires, and cars. The government levied ceiling prices on groceries and rents.

The sacrifices of the folks at home were nothing to those of the young men whose lives were on the battle line. The loss of lives of the young men from Downers Grove was tragic. A plaque listing the names of the men who gave their lives hangs in the American Legion Hall.

At last, after nearly four years of war, the end came when President Harry Truman proclaimed V-J Day on August 14, 1945. Downers Grove went wild with joy that this awful conflict was finally over. Employment opportunities were many as the community shifted to meeting peacetime needs. New homes were being built as the veterans took advantage of their G.I. loans.

The Retail Merchants Association considered changing to the Chamber of Commerce to include professional men in the group. In a light vote in June 1946 the people of the Village voted in favor of a park district with five park commissioners and Otto H. Hummer was named president of the district. Downers Grove was settling down into a new kind of normalcy with the flexibility this village had always shown in meeting the needs of its residents.

Then one spring night in 1947, the resources of the Village were again mustered into immediate action. At 10:41 p.m. the Twin-City Zephyr was speeding through Downers Grove from Minneapolis at its customary 70 miles an hour when it hit a 14-ton International Harvester caterpillar tractor which had fallen from an eastbound freight train. A deafening roar filled the air as the big diesel locomotive, bursting into flames, ploughed through the tracks, ripping up the rails for over 300 yards of the right of way. The diesel engine spun over on its side, skidded past the depot and sprawled across the three main tracks. The first two coaches jackknifed and crashed against the deserted brick railroad station.

Police officers sitting in their squad car watched in horror and immediately radioed for emergency help and rushed to help the injured. Among the first rescue teams to arrive was the Downers Grove Fire Department. The American Legion Hall was open from 11:45 p.m. Thursday night to Friday night feeding the stranded passengers and the many workers helping in the emergency. The theatre lobby was opened to some 65 survivors of the wreck, where first aid was administered. Most of the injured were taken to Hinsdale Sanitarium. There were three fatalities.

By the following day normal train traffic was resumed on the rebuilt three tracks and shortly after, workers began to rebuild the Downers Grove Station. But the sadness of the tragedy for the many victims and the shock of the suddenness of the devastation hung like a cloud over the Village.

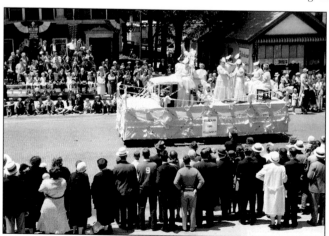

CENTENNIAL CELEBRATION. Despite the gloom of the depression years, Downers Grove celebrated its 100th birthday in 1932 with an all-out celebration! All the townspeople came out to watch the grand parade. The procession travels slowly down Main Street past the Memorial Village Hall draped with bunting and banners. The small frame building to the right is the oldest Village Hall.

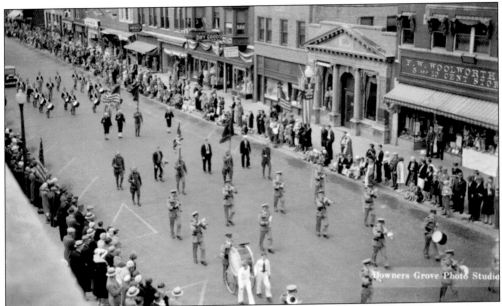

**BANDS AND VETERANS IN THE CENTENNIAL PARADE.** Veterans, accompanied by two bands, march north on Main Street past the businesses on the west side. The parking lines indicate diagonal parking on both sides of Main Street in 1932. Woolworth's Five and Ten was a popular place to shop during the Depression.

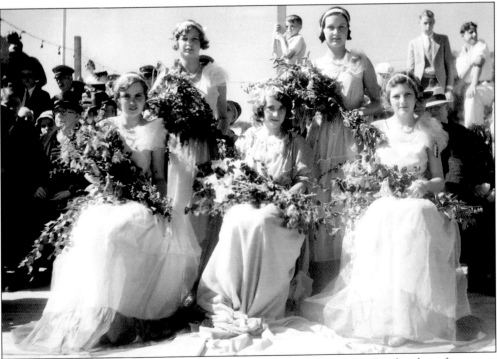

**THE CENTENNIAL QUEEN AND HER COURT.** The sun was shining on the day these five young ladies faced the camera. From left to right they are: (front row) Evelyn Rasch, Centennial Queen Grace Mochel, and Grace Rosenbaum; (top row) Elizabeth Littleford, and Ruth Barnard.

**DR. JAMES HENRY BREASTED.**
Dr. Breasted, a world renowned Egyptologist, archaeologist, and historian, was present at the opening of King Tutankhamen's tomb in 1922. The founder of the Oriental Institute of the University of Chicago, Dr. Breasted was an authority on the history, artifacts, and ancient languages of Egypt and the Middle East. Young James Henry Breasted moved to Downers Grove in 1873 with his family when he was eight years old, and lived in the house his father built, which is still standing at 4629 Highland Avenue. He spent his boyhood here, went through high school at Lincoln School, and then on to North Central College.

A SUNDAY WALK. This picture was taken of the Jones family and the Boal family as they stopped on their stroll through the Maple Grove Forest Preserve. This bench was located on the east-west path just inside the entry from Denburn Woods north of the Avery Coonley property. Pictured from left to right are: (seated) Ruth Boal, Betty Boal, Elsie Jones, Miriam Jones and Dr. Kenneth Earl Jones; (standing) Kenneth Jones and Bill Boal. A walk in the woods was a common Sunday after-dinner activity.

**POST OFFICE CORNERSTONE CEREMONY.** Downer Grove Mayor Henry C. Dicke presided at the laying of the cornerstone for the United States Post Office in 1938. Seated directly behind Mayor Dicke is Mrs. Dora Cline Whidden who was the acting postmaster.

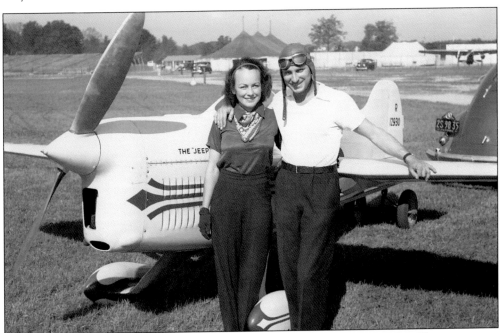

**ART CHESTER.** Born and raised in Downers Grove, Aviation Pioneer Art Chester was an aviator, barnstormer, engineer, and air racer! He designed and built his own personal planes, and participated in air races all over the country. Chester won the 1939 National Air Races in Cleveland when he set a new record speed of 263 mph. He is shown here standing beside his plane with his wife, Trudy. (Photo courtesy of Bob Arehart.)

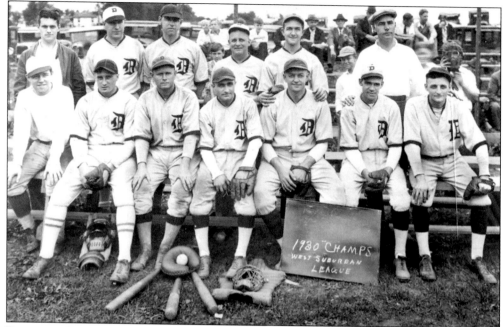

**BASEBALL TEAM.** Pictured is the 1930 West Suburban League champion baseball team of Downers Grove. From left to right are: (front row) unidentified, Eddie Baron, Stan Lynch, Billy Shanabrook, Herb Ehninger, Dutch Bauer, and Jim Karesh; (back row) Horace "Barney" Barnhart, Ray Klein, E.C. "Ted" Curtiss (interesting that Ted Curtiss was a member of the University of Chicago Team which went to Japan in 1920, ten years prior to this team), Harry Sutter (manager.), Art Schaller, and Kent Wyllie (manager, football team).

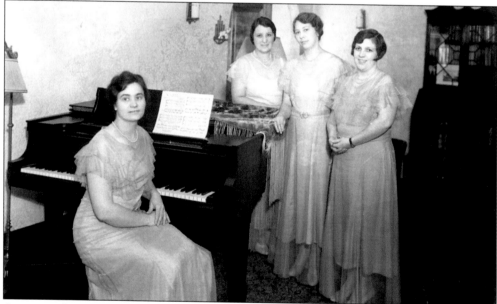

**AMERICAN LEGION TRIO.** The Ilarita Trio of the American Legion Auxiliary posed for this picture in 1934. In the foreground, at the piano, is Esther Binder, the pianist for the trio. Standing from left to right are Alto Agnes Carmody, second Soprano Myrtle Potter, and soprano Gwen Vaughan.

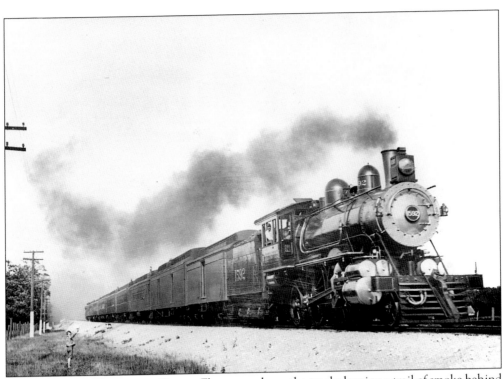

**DENVER FLYER.** The massive Denver Flyer roars down the tracks leaving a trail of smoke behind it. This locomotive #1592 was built in 1899 and was retired in 1932.

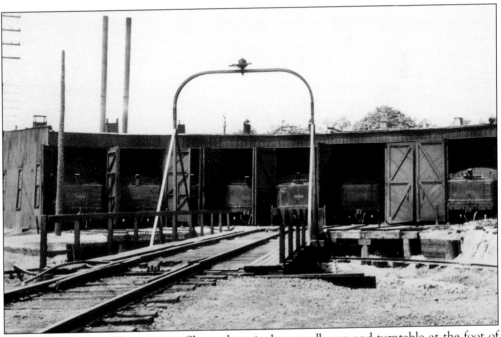

**ROUNDHOUSE AND TURNTABLE.** Shown here is the roundhouse and turntable at the foot of Oakwood Street in Downers Grove. Approximately half of the commuter trains were turned around here and the rest went on to Aurora.

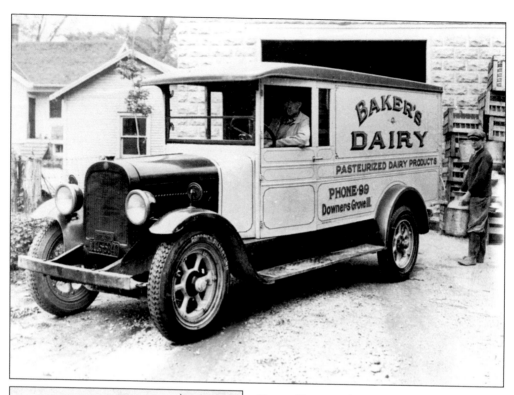

## BAKER'S DAIRY

*Quality Dairy Products*

Office 5125 Main St.         Plant 1122 Warren Ave.
Phone 91                    Phone 999

Downers Grove, Ill., *July 1* 1934

M _G. B. Heartt_
_950 Maple —_

| | | Balance | | |
|---|---|---|---|---|
| *18* | Quart Bottles Milk @ *9* cts. | | | *1 62* |
| | Pint Bottles Milk @ cts. | | | |
| *14* | Jars Cream @ *13* cts. | | | *1 82* |
| | Quart Bottles Cream @ cts. | | | |
| | Jars Whipping Cream @ cts. | | | |
| | Quart Bottles Buttermilk @ cts. | | | |
| | Lbs. Butter @ cts. | | | |
| | Lbs. Cottage Cheese @ cts. | | | |
| | Milk @ cts. | | | |
| | | | Total | *3 44* |

Received Payment _____, 1934

Route No. _1._     By _____

NOTICE -- Customers should Preserve Receipted Bills and Report At Once
Any Errors or Irregularities in Service.

**DAIRY TRUCK.** This truck belonged to Charles Baker, who ran a livery business in Downers Grove for many years, and for a time branched out into the dairy business. Baker eventually sold the dairy business to Cloverleaf Dairy. (Photo courtesy of Bill Hannan.)

**BILL FOR DAIRY PRODUCTS.** This bill shows the dairy order for George B. Heartt on July 1, 1934. His total bill was $3.44 for 18 quarts of milk and 14 jars of cream! (Photo courtesy of Bill Hannan.)

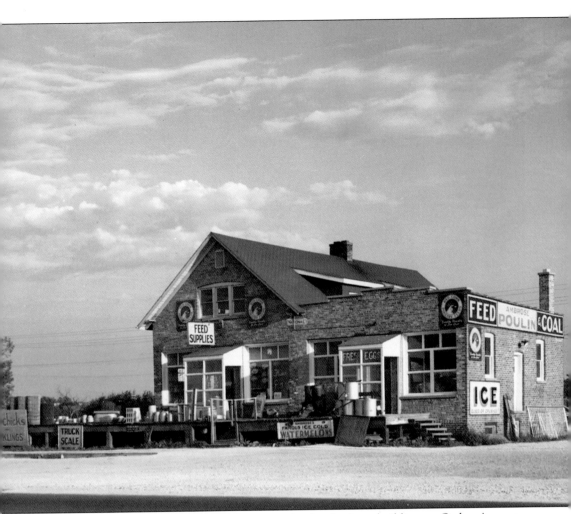

**POULIN FEED STORE.** The Poulin Feed Store was the first business building on Ogden Avenue. Ambrose Poulin bought 18.5 acres in 1919 from Grant Street to Ogden Avenue on both sides of Middaugh and built his own home at 4432 Middaugh. He sold lots on contract and then in 1929 many of the buyers could not pay their payments. When, in 1929, Poulin decided to go into the chicken feed business, he had just $50 in his pocket. He bought 36 bags of chicken feed from a mill in Chicago, and set out to solicit business door to door. After six months he had cleared only $2.50 profit a week! In 1935, he lost his home for a $5,000 mortgage. He decided if he were going to be in business he needed a store, so he cashed in his life insurance and set about to build this building on Ogden Avenue. He got bricks and steel beams from the 1933 World's Fair in Chicago, and customers who owed him money helped him put up the building. Poulin was in business for many years, selling feed, crockery, flower pots, fencing, and almost anything including ice. (Photo courtesy of Evelyn and Gene Poulin.)

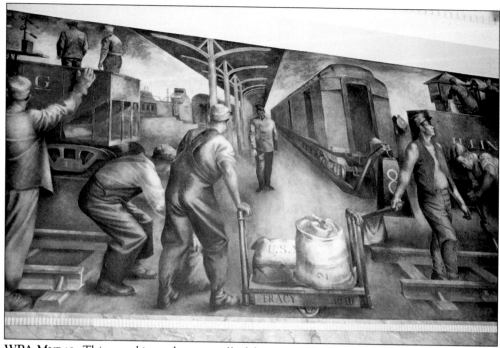

**WPA MURAL.** This mural is on the east wall of the vestibule of the Downers Grove Post Office. The artist or artists are unknown, but it is known that the work was created by artists in the Federal Art Project in Illinois during the Depression years. This agency was under the auspices of the WPA and had the dual benefit of encouraging poor artists and creating interest in works of art. (Photo by M. Dunham.)

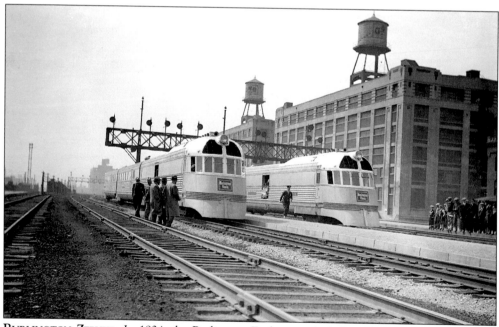

**BURLINGTON ZEPHYR.** In 1934, the Burlington Zephyr streaked through Downers Grove on its record non-stop trip from Denver to the Century of Progress World's Fair at the Chicago lakefront.

**FRED LESTER.** Fred Lester, hospital apprentice first class, lost his life on June 8, 1945 in action with the 22nd Marines against Japanese forces at Okinawa-Shima. For conspicuous gallantry beyond the call of duty, Fred Faulkner Lester was posthumously awarded the Congressional Medal of Honor, the nation's highest citation for bravery. Ten years after the end of the war, the United States Navy named a destroyer escort after Fred Lester.

**MARINE BERNARD A. WEIR.** The pain of the Second World War came swiftly to Downers Grove with the word that Marine Bernard A. Weir had lost his life on the USS Arizona in the Japanese attack on December 7, 1941 at Pearl Harbor.

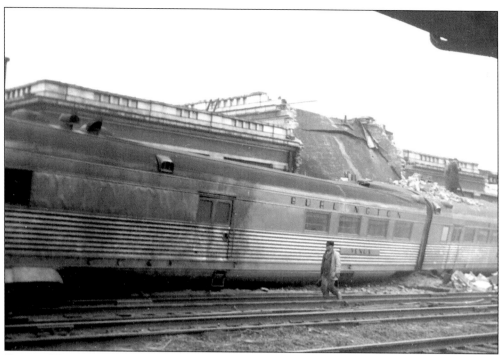

Zephyr Wreck.

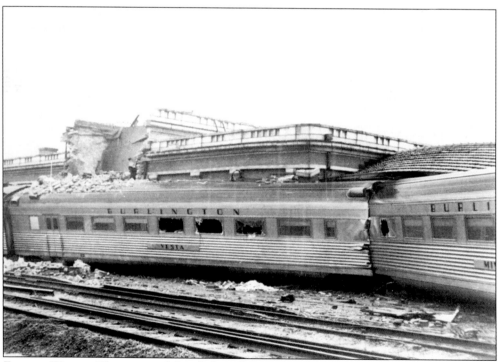

ZEPHYR WRECK. The peace of the dark night was rent with a deafening roar as the diesel locomotive spun over on its side, skidded past the depot, and sprawled across the three main tracks. The first two coaches jackknifed and crashed into the deserted brick railroad station

# Five

# THE GROWING YEARS
# 1947–1982

The population swelled in the years immediately following the end of World War II and the small Village was suddenly confronted by the many needs and concerns resulting from its rapidly ballooning growth.

City dwellers were moving to the tree-lined streets of the villages. Large corporations and governmental agencies were transferring executives to Chicago and these families were choosing to live in the suburbs. The growth of the Village was also affected by the locating of Argonne National Laboratory on 3,645 acres south of Downers Grove. Though Argonne itself was not in the Village, the impact on Downers Grove was great as it brought its employees with their high-level technical and scientific skills to the community. The influence of these families, with their strong values on the need for a fine school system and their involvement in working for the betterment of the community was significant. Downers Grove had the largest concentration of these employees, with Joliet second and Naperville third.

From the beginning, the Village had grown steadily, with the exception of the Depression years, but in the three decades from 1950 the population of the Village had quadrupled in size to 42,560 people in 1980. The rapid increase in population overtaxed every system in the Village. The most basic village services of water, storm sewers, sewage, garbage disposal, streets, and police and fire protection were overloaded, and the school system was faced with providing a quality education for the mushrooming enrollment.

The residents of the Village confronted squarely the need for adjustments in the Village facilities and services to continue providing a good quality of life for the Downers Grove citizens. The pervasive influence stemming from the descendants of the original settlers made for a conservative approach and a concern for fiscal responsibility. This same influence likewise underscored the strong emphasis placed on education. Newcomers to the Village were inclined to the same values and many of these new residents had been drawn to this community for these very reasons.

During these 30 years or so, the residents of the Downers Grove school districts went to the polls again and again for the purpose of raising their own taxes in order to provide schools and teachers for the education of the children of this community. During this period the community of Downers Grove built and staffed nine elementary schools, two junior high schools, one new high school and twenty additions to those buildings and to the older existing schools!

In 1947, some of the industries in the Village were the Schafer Bearing Company, Zollinger Plastic Company, Curran Manufacturing Company, Dicke Tool Company, Precision Steel Warehouse Company, and McCollum Hoist and Manufacturing Company. In the early 1950s, there was an ongoing discussion about whether it would be advantageous to attract more industries to the Village or not. Though there were those who disagreed, the Village embarked on welcoming new industry. Pepperidge Farm was one of the first of the new industries which came to the Village in the 1950s. Ellsworth Park was developed as an industrial park in 1958 bringing a number of industries to the Village.

September 26, 1952 was a landmark date for the Village with the last run of the steam commuter trains and the closing of the Downers Grove roundhouse and train yard. With the all-diesel operations of the commuter trains all the suburban trains would originate and terminate in Aurora.

The opening of the Congress Expressway (the East/West Tollway which was to become Interstate 88) in 1960 changed the life of the villagers of Downers Grove in ways they could not have guessed. This expressway made driving into the center of Chicago a fast and easy alternative to taking the train to the city.

With all the changes, it was becoming more and more evident that the growing Village needed a

new form of government to meet the needs of the residents of the Village. In 1960, former Mayor Ben Groves presented a petition to create the position of a Village Manager, but it was nearly two years before the managerial form of government was approved by the voters.

Problems of taxation, problems of Village Government, problems of adequate schools, problems of zoning, all the problems of the growing Village were met head on by the residents. With every problem, the people of the Village were involved and became active in working toward a solution of the problem. If there were one word, which would characterize the residents of Downers Grove, it would have to be 'involvement'. Groups were formed, information gathered, directions decided, and then together they worked actively to educate the citizens on the issues. The outcomes of the decisions of the majority were accepted for the good of the Village and its people.

The spirit of the Grove prevailed as programs and facilities were put into place for the residents of the Village. Excellent schools were provided for the young people. Funds were raised to build a modern new facility for the Indian Boundary YMCA. The Good Samaritan Hospital opened a 33-million-dollar full-service hospital facility in 1976. A new Kiwanis Club took on as its first project the opening of a Youth Center, and the Community Council was organized which built a Youth Center for a membership of some 850 teenagers. The Village formed the Youth Development Service, which was the forerunner of the Health and Human Services of the Village. The Village established a bus service, which provided commuter service to the train station. This service was unique to Downers Grove, in that it was totally supported by local funds.

The lives of the villagers, during these years of expansion, were also enriched by the cultural activities of the Grove including the Oratorio Society, the Village Forum (which brought well known speakers to the Village), the Downers Grove Community Concert Series, and the many organizations which were active in the Village.

CAMPAIGN PLANS. Betty Cheever and her supporters are laying their plans for her campaign for the Village Council in 1975. Pictured from left to right are Greg Beggs, Betty Cheever, Harry Haberman, and Gordon Goodman. (Photo courtesy of Betty Cheever.)

**MARILYN OSBORNE MANKIVSKY.**
Marilyn grew up in Downers Grove
and received her nurse's training
at St. Luke's. In the late 1940s and
early 1950s, she was a 'courier' on
the Atchison, Topeka and Santa Fe.
The railroad staffed each of their
trains with a registered nurse, called a
'courier,' for the safety and care of their
passengers. The assignment was similar
to that of the stewardesses on the
airlines, except that the couriers did
not have any beverage or food service
duties. Marilyn was usually on the
Chicago to Los Angeles run though
she was sometimes scheduled on a
Texas run. This picture shows Marilyn
in her uniform at the end of the line,
probably in Galveston, Texas. (Photo
courtesy of A. Mankivsky.)

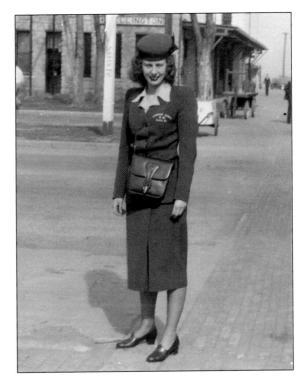

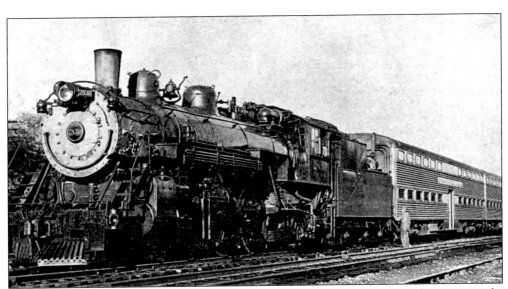

**SEPTEMBER 26, 1952.** Pacific Locomotive 2830 pulls four new gallery cars and a power car for
the last run of a steam locomotive of suburban trains, as well as the last day for the operation
of the Downers Grove roundhouse and turntable.

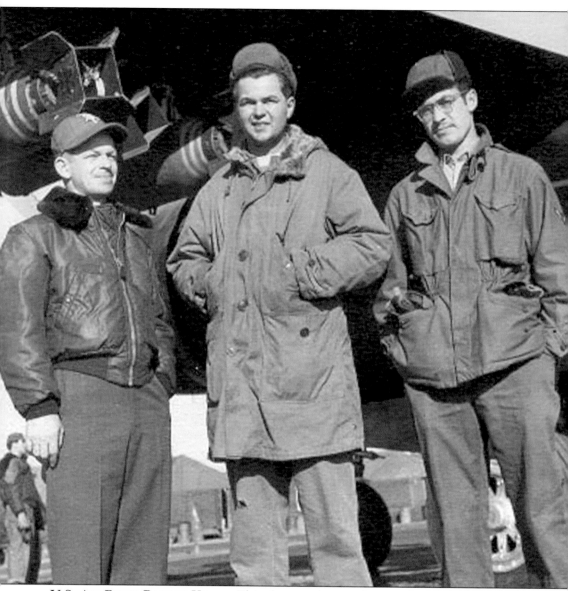

**U.S. AIR FORCE BASE IN KOREA.** This photograph was taken on the 22nd of January 1953. Pictured from left to right are Maj. Jack "Shorty" Powers, Sgt. Robert Jensen, and Pfc. William Berry. Major Powers, as a B-25 bomber pilot in the Korean War, completed 55 missions in six months. He also was a C-54 pilot in the Berlin airlift and flew off carriers in World War II. Later Lt. Col. "Shorty" Powers, with some 18 years of service, was named public affairs officer for all of the Project Mercury manned space flights, including those made by Shepard, Grissom, Glenn, Carpenter, Schirra, and Cooper. "Shorty" Powers became a national celebrity as the voice of the astronauts! (Photo courtesy of Bob Jensen.)

**MISS AMERICA 1948.** BeBe Shopp is shown here with crown and royal scepter as she was named Miss America in 1948. BeBe grew up in Downers Grove but moved to Minnesota when she was in high school. Named Miss Minnesota, she went on to the Miss America pageant to be crowned Miss America! (Photo courtesy of Bea Waring.)

**SHERRILL MILNES.** Sherrill has been recognized as one of the greatest baritones of his day. He has sung in opera houses all over the world and has sung opposite such stars as Placido Domingo, Luciano Pavarotti, Beverly Sills, Renata Scotto, Leontyne Price, Joan Sutherland, and many others in his 30 some years at the Metropolitan Opera. Milnes is a descendant of one of the earliest pioneers in the Village, Dr. Franklin K. Roe. The Roe family was remarkable for the musical contributions made by its members to the community. Thelma Roe Milnes, Sherrill's mother, was the director of the church choir and also director of the Downers Grove Oratorio Society. She saw to it that Sherrill had piano and violin lessons, and vocal training. He first sang in the church choir under his mother's direction. He is shown in this picture accepting one of the many honors he has received throughout his distinguished career. (Photo by Ed Bunting Jr.)

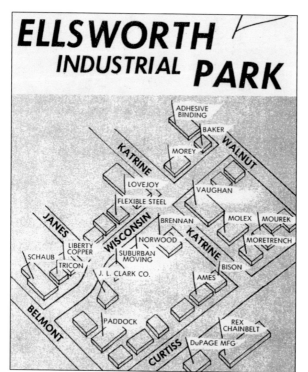

**ELLSWORTH INDUSTRIAL PARK**

ADHESIVE BINDING
BAKER
KATRINE
MOREY
WALNUT
LOVEJOY
VAUGHAN
FLEXIBLE STEEL
JANES
WISCONSIN
BRENNAN
MOLEX
MOUREK
KATRINE
LIBERTY COPPER
NORWOOD
MORETRENCH
SCHAUB
SUBURBAN MOVING
TRICON
BISON
J. L. CLARK CO.
AMES
BELMONT
PADDOCK
REX CHAINBELT
CURTISS
DuPAGE MFG

**ELLSWORTH PARK.** This map shows the businesses included in Ellsworth Park, which was developed in 1958 by Raymond Lopata.

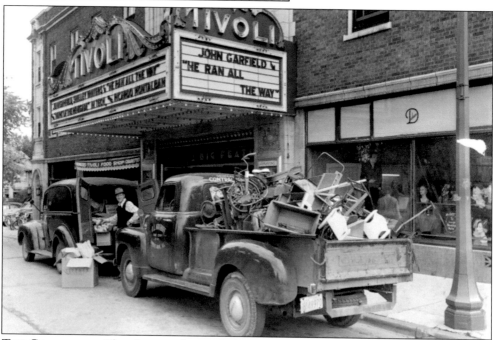

**TOY COLLECTION.** The photographer took this picture of Building Contractor O.L. Krughoff loading his truck with toys for the Kiwanis "Toys for Kids" project. The Kiwanis Club then repaired, painted, and refurbished the toys to give to needy kids at Christmas. Note the movie being shown at the Tivoli in 1951, *He Ran All the Way,* with John Garfield, Shelly Winters, and Gladys George.

**BICENTENNIAL FIREPLUG.** A walk or drive down the streets of Downers Grove in the summer of 1976 would have found a small army of brightly colored fireplugs block after block! On closer scrutiny, they were short, fat likenesses of the patriots of 1776. The villagers painted the fireplugs to resemble the fathers of our country. One might see George Washington, Paul Revere, or Benjamin Franklin, and on and on. They were a visible reminder of our heritage. (Photo by Bob Dunham.)

**BICENTENNIAL MURAL.** The Village was festive with the decorations for the 200th birthday year of our country! This huge mural of the fathers of our country was painted on the side of an office building on the east side of Main Street just south of Maple Avenue at the site of the present Morningside Condominiums. (Photo by Ed Bunting Jr.)

**LOTTIE HOLMAN O'NEILL STATUE.** In 1976, Lottie Holman O'Neill was honored with a bronze statue in her likeness on the second floor rotunda of the State Capitol in Springfield. Among those representing Downers Grove at the dedication of her statue were, from left to right, Mr. and Mrs. Paul Backlund, State Rep. George "Ray" Hudson, and Downers Grove Park Board President William "Bud" Sherman. With the dedication of this statue, O'Neill set another first as she became the first woman to be represented in the rotunda. (Photo from Downers Grove Reporter.)

**BICENTENNIAL POSTER.** This poster depicting early Downers Grove was created by three Downers Grove South High School students: Monique Aduddell, Rick Cristofan, and Kim Fuka.

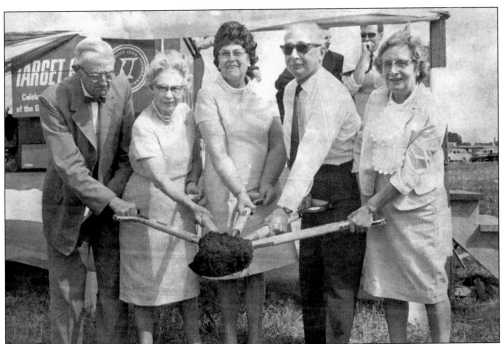

GROUNDBREAKING. The first shovel of dirt for the new Indian Boundary YMCA was turned by, from left to right, Irving Heartt, Clara Lacey, Thelma Roe Milnes, James Milnes, and Adelyn Lyness. Many businesses and individuals contributed to the building fund. Gifts from the James and Thelma Milnes family totaled more than a half million dollars, and Irving Heartt, Clara Lacey, Mrs. John Mochel Sr., and John Mochel Jr. also made sizeable contributions. (Photo courtesy of the Indian Boundary YMCA.)

INDIAN BOUNDARY YMCA. The dedication ceremonies for this new building, which was dedicated to James and Thelma Milnes, were held on November 16, 1969. One of the rooms in the building was designated the Sherrill Milnes Music and Fine Arts Room. Sherrill has given many benefit recitals at the YMCA. (Photo by M. Dunham.)

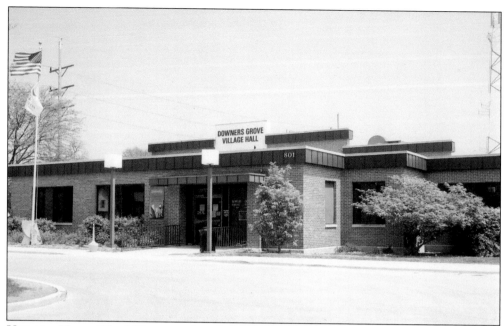

**VILLAGE HALL.** The Village purchased this building at 801 Burlington from the Schafer Bearing Company and completely remodeled the facility into a new Village Hall. The Village of Downers Grove moved from the old Memorial Village Hall on Main Street into this new Village Hall in 1969. (Photo by M. Dunham.)

**VILLAGE HALL.** The Village Council Chambers are in this section of the building. The Village Civic Center includes the Village Hall, the maintenance facilities to the east of the Village Hall, the Downers Grove Police Department building, and the Social and Health Services building at the west end of the complex on Curtiss Street. (Photo by M. Dunham.)

**Pauline Wandschneider.** This picture shows Pauline descending the stairs at the grand opening of the Downers Grove Historical Museum in the Blodgett House at 831 Maple on the 30th of January, 1977 to greet some 300 guests. Pauline was the true founder of the museum as she enthusiastically gathered the bits and pieces of the history of Downers Grove, whether information or artifacts. The first historical museum was opened on the second floor of the Village Hall in 1969. The second home of the museum was in a house at 842 Curtiss Street, which had been purchased by the Downers Grove Park District in the fall of 1973. Three years later, the Park District sold that house to the Village and bought the Blodgett house, and the museum moved into its new home.

**THE DOWNERS GROVE PARK DISTRICT MUSEUM.** This is the Blodgett House which was built the year before the Columbian Exposition in Chicago by Charles Blodgett, the youngest son of Israel and Avis Blodgett. It was a year that a number of new homes were built in Downers Grove. This was the third house on the property. Charles Blodgett was born in the log cabin that Israel Blodgett Sr. had built when he and Avis settled the land in 1836. Then, in 1849, Israel built a frame house to replace the log cabin. Israel and Avis were ardent abolitionists and provided safe haven and food for many fleeing slaves in their home as a station on the Underground Railroad. When Charles had the frame house moved to Randall Street, he built this large Victorian house over the basement of the 1849 house. One can not say with certainty that slaves had been hidden there, but it is certainly likely. This house was completed in 1892 and the Blodgett family lived here until 1932. The Downers Grove Park District purchased the property in 1976 and the museum was opened to the public on January 30, 1977. (Photo by M. Dunham.)

# Six

# At the Turn of the 21st Century
## 1982–2003

These last 20 years or so of the 20th century and the first years of the 21st century have been exciting, productive years for the Village of Downers Grove. The Grove was becoming a mature town, growing and filling out into its borders. Lots for additional building were disappearing with virtually all the land built upon. Some people are clearing lots of their existing houses in order to have space to build large new homes. On the other hand, there are those who are buying older homes and restoring them to their original architectural integrity.

Downers Grove marked its 150th birthday in 1982; and what a year it turned out to be. A grand celebration was planned for the sesquicentennial. The villagers had always favored parades and celebrations and the first Heritage Fest held in 1982 was a spectacular event with activities and entertainment for everyone! Heritage Fest was such an overwhelming success that it has been held every year since.

In 1983, the voters of Downers Grove went to the polls and elected their first woman mayor, Betty Cheever. She was reelected three more times for a total tenure of 16 years of competent leadership. Cheever was well-prepared for the office of mayor. She had served on the Downers Grove Plan Commission from 1970 to 1975, when she was elected a Downers Grove Commissioner. She was a Commissioner on the Downers Grove Village Council for the eight years from 1975 to 1983, prior to being elected mayor of the Village. Cheever made the decision not to run in 1999. Brian Krajewski ran for mayor in 1999 and was elected by an enthusiastic majority. Krajewski, an active and involved mayor, was reelected in 2003.

The Village, from the beginning, has produced talented people renowned in their fields, and this 20 year period has been no different. There are scientists, educators, authors, Olympic gold medalists, and entertainers who call Downers Grove home.

A few of these outstanding achievers are: Sherrill Milnes, opera star; John Powers, author; Cammi Granato, Olympic Gold Medalist; Philip Soltanek, comedian, known professionally as Emo Phillips; Jill Peters, actress; Lauren Frost, young actress and singer; Gale Doss, opera star; Barbara Stock, actress; Andrea Evans, actress; Denise Richards, actress; Nancy Napolski Johnson, Olympic gold medalist; and many others.

During these years, the Village was growing within its boundaries and redeveloping. The location of the Village as a center of transportation with the confluence of the Interstate Highways, the railroad, and proximity of O'Hare and Midway Airports, made it a desirable location for offices, businesses, and industry, and many new businesses and industries made Downers Grove their home. A sizeable number of office complexes were built and industrial areas developed. The Village gained shopping malls at either end—north and south, and the Central Business District was renewed and revitalized. Downers Grove has welcomed the progress in the Village while cherishing and preserving the traditions of the past.

Three 100-year businesses thrived in the Village. Mochel's Hardware, which was founded in 1884, was the 100-year-old retail business owned and operated by the same family for all those years. In 1984, Mochels Hardware celebrated its 100 years in business. The Downers Grove Reporter was founded in 1883, and though there were several owners in the early years, it was purchased by Christian Staats in 1908 and remained in the Staats-Winter family, until it was sold recently. Casper

Dicke started his machine shop in Chicago in 1886 and moved it to Downers Grove three years later. This was the first industry in Downers Grove and is still in operation.

In August of 1998, the Village embarked on the largest public works project ever undertaken in the history of the Village. This four phase, three-year project included the removal and replacement of all the water mains, storm sewers, sanitary sewers, public streets, curbs, sidewalks, streetlights, and traffic signals in the Central Business District. A large parking facility is planned and underway.

The project also included the beautification of the Central Business District. Aesthetic improvements included a new cemetery wall, a water fountain in the plaza area of the Main Street Railroad Station, and numerous seat walls defining the flower planting areas. In addition, 140 trees were planted in the downtown area.

In 2003, living near the rail line is still very desirable, and an alternate form of housing to the traditional single family homes is being offered in the center of the Village. Three new elegant housing areas have been developed: Morningside Condominiums on Main Street, Georgian Courts Town Homes between Curtiss and Gilbert Streets, and Station Crossing, a mixed development of condominiums and ground level retail businesses, bounded by Main, Rogers, Highland, and Warren Streets just north of the train station.

In Downers Grove there is almost always something going on. A stroll through the Central Business District in the summer of 2003 finds brightly decorated wheelbarrows, many laden with flowers. At the end of the summer, the wheelbarrows will be auctioned off with the proceeds going to the Downers Grove Library.

The exciting Heritage Fest is traditionally the last weekend in June, followed by the 4th of July Parade, and then the Bike and Buggy Parade. Concerts in the Park, sponsored by the Downers Grove Park District, are held every Tuesday night throughout the summer. On Friday nights, Main Street is like a carnival as people amble up and down the street eyeing and admiring the classic cars. In August, the International Pro-Criterion Cycling & In-line Skating Championship Races are held. And then there are special events at the Downers Grove Park District Museum, the Fine Arts Fair, Halloween Costume Parade, Christmas Parade and Tree Lighting, and an Ice Sculpture Festival in January. Something for everyone!

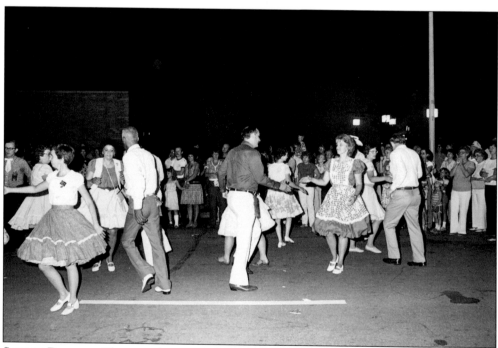

SQUARE DANCING. There was dancing in the streets at Heritage Fest! These onlookers are enjoying watching the square dancers as they demonstrated their steps! (Photo by Ed Bunting Jr.)

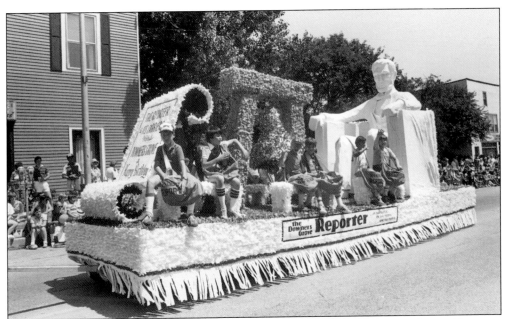

**FOURTH OF JULY PARADE.** The parade at Heritage Fest of 1982 was replete with many elaborately decorated floats and marching bands. This picture shows the float of the Downers Grove Reporter. (Photo by Ed Bunting Jr.)

**HERITAGE FEST.** The 1920 White Pumper, the first mechanized piece of equipment of the Downers Grove Fire Department, led the parade of modern day fire equipment in the 1982 Fourth of July Parade. The Downers Grove Fire Department purchased this 1920 White Pumper on February 4, 1921. The money for the White Pumper was raised by donations from the residents. Two members of the volunteer fire department, Henry Dicke and Valentine Wander, mortgaged their homes to contribute funds to meet the cost of $10,000 for the purchase. This truck can be seen on display at the Downers Grove Park District Museum. (Photo by Ed Bunting Jr.)

**MOCHEL'S HARDWARE.** This picture of Doris and John Mochel Jr. was taken at the grand 100 year celebration of the founding of Mochel's Hardware store. (Photo courtesy of John Mochel Jr.)

**MOCHEL'S HARDWARE CENTENNIAL.** On the left is John Mochel Jr., owner of Mochel's Hardware Store, with his son Larry on the right at the 100 year celebration. Larry died in 1990 as the result of a tragic automobile accident in 1986. (Photo courtesy of John Mochel Jr.)

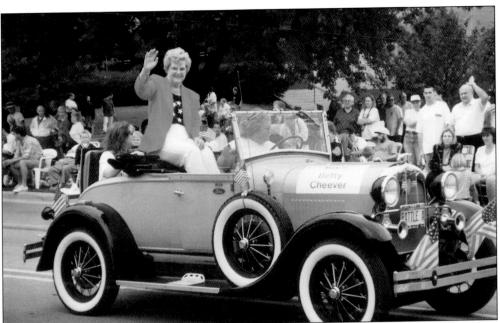

**MAYOR CHEEVER.** This photo shows Mayor Betty Cheever waving to the residents lined up along the 4th of July parade route. At the mayor's first council meeting in May 1983 the question was brought up on how one should address the mayor, since the Village code called for the title "Mr. Mayor." After a short discussion, the council agreed on addressing the head of the Village as "Mayor Cheever," rather than Madame or Mrs. Mayor. (Photo courtesy of B. Cheever.)

**DGTV—CHANNEL 6.** DGTV staff is shown interviewing Bebe Shopp, Miss America of 1948, at the 100 year celebration of Mochel's Hardware. Dave Garrity is the reporter interviewing Bebe Shopp and Jim Dunham is the photographer. The young girl at the right is Adrienne, the granddaughter of Doris and John Mochel Jr. (Photo courtesy of John Mochel Jr.)

CAMMI GRANATO. A real hometown hero for the Village of Downers Grove—Cammi Granato was captain of the gold-medal winning U.S. Women's hockey team in the 1998 Olympics and a member of the silver-medal U.S. team in the 2002 Olympics. The Village honored the gold medalist with a parade with more than 20 groups from hockey teams to marching bands concluding with a rally at Downers Grove North High School. This picture was taken when Cammi visited students at Highland School and Herrick Middle School. In a ceremony which has become a tradition between the pupils and Cammi, the Highland pupils lined the hallways where each student could high-five the Olympic champion. (Photo courtesy of the Downers Grove Reporter.)

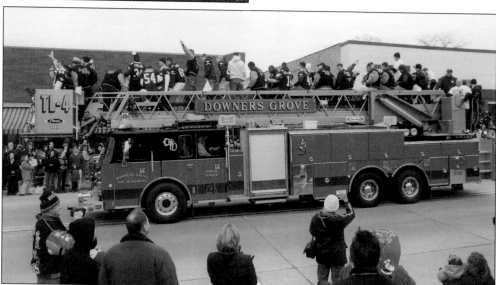

FOOTBALL CHAMPIONSHIP PARADE. A festive parade was held for the Downers Grove South High School Football Team when they won the IHSA Class 8A Illinois State Championship. The team rode atop the fire equipment down Main Street to the cheers of all the supporters of our Downers Grove High Schools. This is one of the many accomplishments and championships captured by the boys' and girls' teams at both Downers North and Downers South High schools! (Photo courtesy of D.G. Downtown Management Corp.)

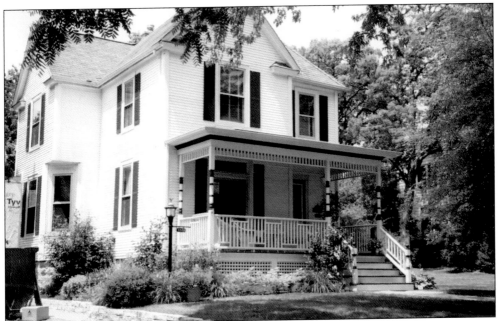

**HISTORIC HOME.** This historic home at 4824 Saratoga Avenue is still undergoing the building of an addition in 2003. Owners Julianne and Sean Coughlin have completed the restoration of the front porch to the exact duplication of the original home, based on information which they gained from a descendant of the original owner. (Photo by Julianne Coughlin.)

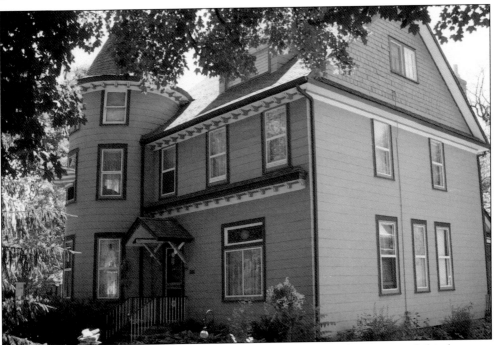

**HISTORIC HOME.** Mary Ann Bokholdt and her son Alex are the owners of this home at 731 Maple. This handsome house with its elegant turret was built in 1900. It is painted in the style of the times with three contrasting colors (Photo by M. Dunham.)

**MAYOR CHEEVER WITH BOB SHOGER.** Pictured with Mayor Betty Cheever is long-time Village employee Bob Shoger whose most recent title was Central Business District Infrastructure Manager. (Photo courtesy of B. Cheever.)

**FOUNDER'S DAY.** As the residents of Downers Grove were honoring Founder's Day, the streets were teeming with costumes and personalities from the 1860s. Note the Abe Lincoln impersonator in the center background giving a speech. (Photo by Ed Bunting Jr.)

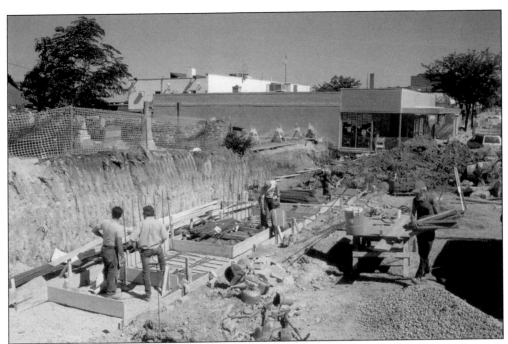

**DOWNTOWN RE-DO.** This photo, taken looking north, shows the excavation of Main Street in the Central Business District. One hundred-year-old water mains, sanitary sewers, and storm sewers were dug up and replaced. All sidewalks, curbs, street surface, streetlights, and traffic signals in the center of town were removed and replaced. (Photo courtesy of the Village of Downers Grove.)

**TEARING UP BEFORE FIXING UP.** Looking south on Main Street at the deep excavation of Main Street. The project was divided into four phases with each phase beginning in March and ending in October. Phase One began in 1998 and Phase Four was completed in September of 2001. Totals for the project included 20,000 linear feet of curb and gutter; 9,500 linear feet of water main; 7,500 linear feet of storm sewer; 8,500 feet of sanitary sewer; 19,000 linear feet of road surface; 137,000 square feet of sidewalk; and 215 ornamental streetlights. (Photo courtesy of the Village of Downers Grove.)

(*top left*) **THE BANNER.**

(*top right*) **ESPLANADE OFFICE BUILDINGS.**

(*left*) **EXECUTIVE TOWERS OFFICE BUILDINGS.**

**ECONOMIC DEVELOPMENT.** In the past 20 years, extensive office complexes have been developed. In the Northwest Territory of Downers Grove, the Esplanade area is home to many large corporations, as well as in the Executive Tower area. Many companies are located in the Highland Landmark Complex just off Thirty-first Street, and in the Corridors Complex on Warrenville Road. The banner displayed throughout Downers Grove presents the motto of the Village, "Downers Grove Preserves the Balance Between Tradition and Progress." (Photos by M. Dunham.)

**MORNINGSIDE CONDOMINIUMS.** This is a recently built condominium building on Main Street just south of Maple. (Photo by Phyllis Betenia.)

**STATION CROSSING.** This is a large mixed use building with condominiums and space for retail businesses and shops on the first level. This building is just north of the Railroad Station and bounded by Main, Gilbert, Highland, and Rogers Streets with the main entrance on Rogers Street. As of 2003 this building is still under construction but moving rapidly toward completion. (Photo by M. Dunham.)

**ADVOCATE GOOD SAMARITAN HOSPITAL.** This aerial view shows the large campus and extensive buildings of the Advocate Good Samaritan Hospital in 2003. This 302-bed facility has more than 700 physicians on staff representing 55 specialties. The hospital has a Level I Trauma Center and a Level III Perionatal Center (the highest designations). Good Samaritan Hospital offers exceptional healthcare services, including emergency medicine, cardiac care, women and children's services, oncology, and surgical services. This picture also shows the building of the new Health and Wellness Center, which provides services to some 4,400 members. (Photo from Good Samaritan Hospital.)

**GEORGIAN COURT TOWNHOMES.** In process of completion, these townhomes are between Curtiss and Gilbert Streets west of Forest Avenue. (Photo by P. Betenia.)

# Seven

# THE CHURCHES AND SCHOOLS

The earliest pioneers in the Grove reached out for religious services. Itinerant circuit riding preachers held services in the settlers' cabins for all who wanted to come. For all their hard work in turning the prairie into arable fields, the tending of their livestock, building their cabins, and simply surviving, on Sundays these pioneers gathered together to worship.

The earliest organized churches in the Grove were the First Methodist Church, the First Baptist Church, the First Congregational Church, the Faith Evangelical United Brethren Church, and St. Paul's Evangelical Church. It is an interesting insight on the number of German-speaking people in the Grove that both the Faith Evangelical United Brethren Church and St. Paul's had preaching services in German. Many of their congregations had come from Alsace-Lorraine. These early churches are all still active congregations in Downers Grove, and through the years all of them have built new church buildings. Some of them have changed locations. The First Methodist Church, the First Congregational Church, and the First Baptist church are each in their same downtown locations, while St. Paul's moved from Grove Street to Dunham and Jefferson, and Faith Methodist (previously United Brethren) moved to Fifty-ninth Street and Fairview. These five earliest churches in the Village have been joined by a host of other churches in Downers Grove, including St. Andrew's Episcopal Church, St. Joseph's Catholic Church, St. Mary's Catholic Church, the First Church of Christ Scientist, and Immanuel Evangelical Lutheran Church, all of whom are either very close to being 100 years old or have already celebrated their centennial anniversaries. In addition to these named churches there are another 20 or more active church congregations in Downers Grove.

As well as their need for religion, these resolute, hardy settlers recognized the need to provide an education for their children. In 1836, Israel Blodgett built a lean-to against his log cabin as a school room, which would provide an education for his own children and any of his neighbors' children who would choose to attend. It is said that 12-year-old Mary Blodgett was the teacher until Hiram Stillson (or Willson) was hired to teach. Dexter Stanley also built an early school and his daughter Nancy Stanley Bush was said to be the first teacher in the district when she taught in this school in 1837.

In 1846, Downers Grove became a recognized school district, and a small frame schoolhouse was built at Maple and Dunham Roads. This one-room school served for 21 years until a new brick two-room school was built in 1867 at the location which later became Lincoln School on Maple Avenue. In 1876, the school was graded and a 10-year course of instruction was adopted including two years of high school work. As the number of students continued to grow, two additional rooms were added and the first class of students graduated in 1879. There were five students in that graduating class.

In 1890, when there were some 400 students in the Downers Grove Schools, the citizens voted to form a Board of Education. In 1891, the two-room Washington School was built north of the tracks on Washington Street and just two years later, two additional rooms were added to that school.

The northern section of Lincoln School was added in 1900 to the front of the original four-room school building. Then, in 1913, the four-room building was taken down in order to build the new high school building on that site at the rear of the Lincoln Grade School. This high school served for 15 years until the Downers Grove Community High School was built on Prince Street in 1928.

On April 19, 1902 the original School District #2, which had been formed in 1846, became District #58. Some 20 years later, in 1923, District #99 was formed as a separate Community High School District.

Whittier and Longfellow Elementary Schools were built in 1927. These schools, along with Lincoln School, served the community until the building boom of the post World War II years when 11 additional elementary schools were built in rapid succession to meet the educational needs of the children of the growing community. From those 400 students in 1890, the enrollment in the district has

grown to more than 5,000 students.

Downers Grove Community High School (now Community District #99 North High School) has had many additions through the years, the most recent in 2002. Downers Grove Community South High School was built in 1964 and has had two large additions—the first in 1969, and the second in 2002. The enrollment during the 2002–2003 school year in District #99 was approximately 5,300 students. From January to June of 2002 District #58 celebrated the very special milestone of their 100-year anniversary with various school and community activities.

Other schools in Downers Grove include St. Mary's Catholic School, St. Joseph's Catholic School, and Avery Coonley School. St. Mary's first grade school was opened in 1897 in a small wooden building. A simple wood wall partitioned the room into two small classrooms. The school was staffed with male lay teachers until the Franciscan sisters came in 1915. The Felician Sisters came in 1919 and have directed the school continuously since that time. The school was moved in 1920 to a new two-story brick building on Franklin Street. In 1954, the parish constructed a building of 13 classrooms for the growing school at Prairie and Douglas and then, in 1978, an addition to this school was built. St. Mary's now has 20 classrooms plus other facilities. In 2003, the school has 675 students in classes from pre-school through eighth grade.

St. Joseph's opened its first grade school in 1910 in a large room in the church. In 1918, when the growing school needed additional space, a room in the convent was used. Shortly thereafter a second room was needed, and three Ursuline Sisters taught the students. In 1925, an eight-room school was built on the corner of Highland and Franklin and opened with six nuns teaching the students. In 1931, the Sisters of Providence took over as teachers. In 2003, there are two homerooms for every grade from kindergarten through eight.

The school, which became Avery Coonley School, was founded in Riverside in 1906 by Mrs. Avery Coonley in a cottage on her estate. With increasing enrollment and the need for larger quarters, Mrs. Coonley opened the first kindergarten in Downers Grove on Grove Street in 1912. Through the years, the school increased from a kindergarten to a school with two years of kindergarten up to and including the sixth grade. Mrs. Avery Coonley, president of the association, bought 11 acres from the Ducat estate on Maple Avenue just west of Dunham Road. A large building was erected for the school in 1929 and the name changed to Avery Coonley School. By 1933 there were over 150 students enrolled in all the grades from kindergarten through eighth grade, and the reputation of the school grew across the country. The outstanding program consistently drew bright, highly motivated students, and in the 1960s, the Board of Trustees officially adopted this emphasis. In 2003, the enrollment at this independent school is 362 students.

Downers Grove was also home to George Williams College, a liberal arts college accredited by the North Central Association of Colleges, from 1966 to 1986 when the campus was sold to the Chicago College of Osteopathic Medicine (now known as Midwestern University).

Midwestern University was founded in Chicago in 1900 as the American College of Osteopathic Medicine and Surgery by J. Martin Littlejohn, Ph.D., MD DO. In 1986, Midwestern University (at that time The Chicago College of Osteopathic Medicine) purchased 104 acres with the college buildings from George Williams College and moved from their Hyde Park Campus to the Downers Grove Campus. This campus is located at 555 Thirty-first Street, and is bounded on the west by Lyman Woods. Following the relocation of the College, the Board of Trustees voted to begin the development of new academic programs within the health sciences. As a result of this decision, the University now consists of the Chicago College of Pharmacy and the College of Health Sciences, which includes the Physician Assistant Program, the Physical Therapy Program, the Occupational Therapy Program and the Biomedical Program. Midwestern University awards degrees at both the undergraduate and graduate level. As of 2003, the Downers Grove Campus has 16 buildings that include academic classrooms, laboratories, a new state of the art library, and auditorium building, and student housing.

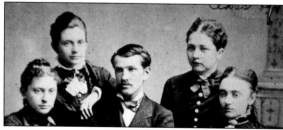

**FIRST HIGH SCHOOL GRADUATING CLASS–1879.** These four young ladies and one young man were the first graduates of the ten-year graded program at Lincoln School. They are, from left to right, Cora F. Wood, Mary E. Briggs, Frank S. Puffer, Lulu H. Stanley, and Abbie M. Andrews

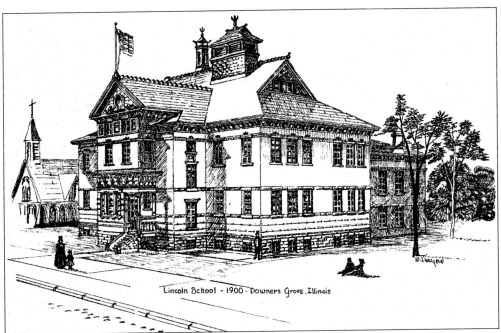

**LINCOLN SCHOOL.** This drawing depicts Lincoln School in 1900. Note the old school building to the right rear, and the First Baptist church to the left. (Picture by Wes Vineyard.)

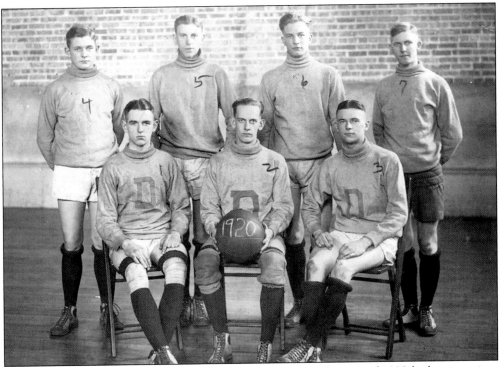

**BASKETBALL TEAM.** The members of the Downers Basketball Team of 1920 look very serious as they sit for their portrait. From left to right are: (front row) Ben Allison, Rich Shurtz, and Harold Gumhausen; (back row) Roy Phelps, Bruce Busen, Gus Boone, and ? Morton.

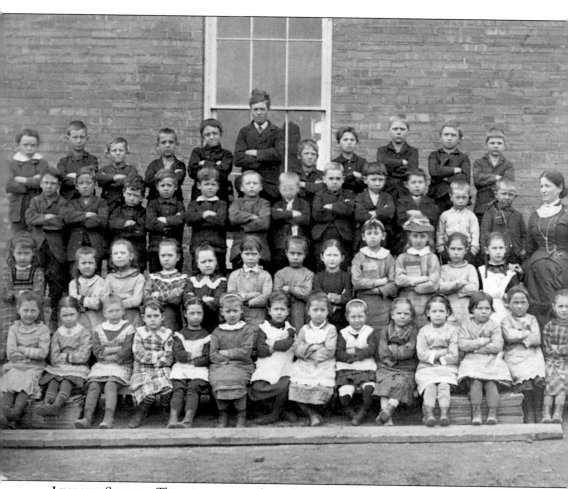

**LINCOLN SCHOOL.** This picture was taken of teacher Miss G.A. Fitch and her schoolroom of pupils in 1883 or 1884. The names of the children, from left to right, are: ( front row) Frances ?, Mabel Blanchard, Gracie ?, Mabel Hill, Maud Seaton, Annie Wetten, Fannie Woods, Martha Nicklet, Lizzie Noel, Jeanie Smith, Ida Daw, Lena Tripp, Mary Smith, and Mamie Sass; (second row) Tealie Austin, Maud Huff, unidentified, Fannie Colwell, Florence Group, Rosie Coochel, Ella ?, Ella Biedelman, Birdie Rockwell, Florence Bates, Ida Nicklet, and Emma Holloway; (third row) Frankie ?, unidentified, Johnny Dean, unidentified, George Ridgeway (died during the school year), ? Ridgeway, Freddy ?. Georgie Cordess, David Blodgett, Theo. Lyons, Earl Taylor, and Charlie Hall; (fourth row) Stephen Kidney, H. Barr, Corun Haggart, unidentified, Earl Seaton, Walter Cooms, Eddie Moghel, unidentified, unidentified, Lony Coal, and unidentified. The student/teacher ratio looks very large, but Miss Fitch still seems to have the classroom under perfect control. Notice how each one of the young students has his/her arms neatly folded.

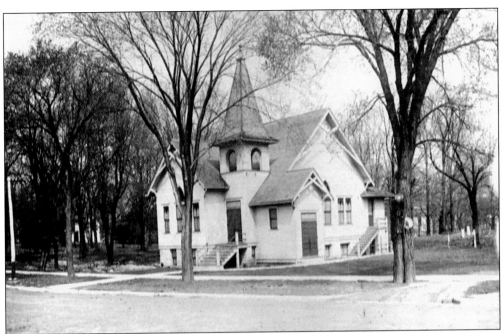

**ST. PAUL'S EVANGELICAL CHURCH.** In July of 1897, the congregation of St. Paul's bought a lot on Grove Street near Main Street from the Henry Bush estate for $300 and built this building in 1908. Until 1911, all the worship services were in German, and for many years one worship service a month was in German. The church relocated to Dunham and Jefferson Streets in 1956, and is now St. Paul's United Church of Christ.

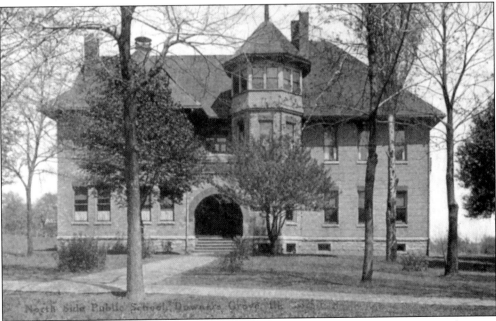

**WASHINGTON SCHOOL.** This photo is of Washington School which was built on Washington Street north of the tracks in 1891. An addition was built in 1924 and the school was enlarged again with another addition in 1927.

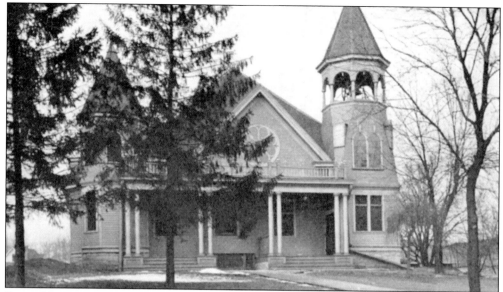

**FIRST METHODIST CHURCH.** This is the First Methodist's "Welcome Church," which was built in 1894. The first Methodist circuit preachers held meetings in the log cabins of the early settlers. In 1853, the Methodist congregation built their first church building at the site of their present church on land donated by Henry Carpenter, who was not even a member of the church. In 1880, the church was rebuilt, and in 1894 this "Welcome Church" was built. The present church was built in 1928 with sizeable additions in 1968 and 1988.

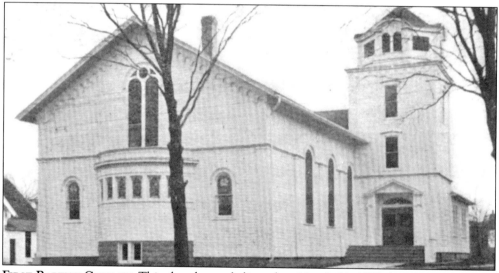

**FIRST BAPTIST CHURCH.** This church was dedicated on March 24, 1872, less than a year after the previous church building had been destroyed by fire. Samuel Curtiss donated the land for that first church, which had been built in the fall of 1853. The church was founded in 1851. The first services were held in the schoolhouse and baptisms took place in St. Joseph Creek. In midwinter, often five or six inches of ice had to be chopped away for the baptisms. The present day handsome brick church was built at the same site as the historic church, and another addition is in process of completion.

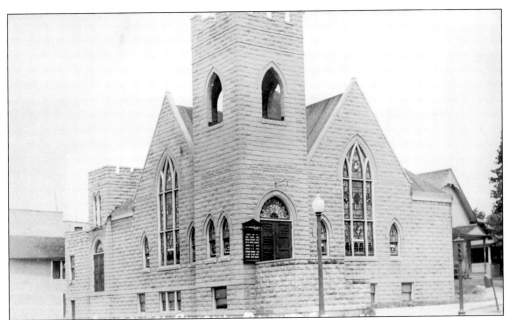

**FAITH EVANGELICAL UNITED BRETHERN CHURCH.** The building shown in this picture was built at the corner of Main Street and Maple in 1909. The congregation met first in a building on Belmont Road and the first services were entirely in German. This church is presently at the corner of Fairview Avenue and Fifty-ninth Street and is now the Faith United Methodist Church. (Photo from John Mochel Jr.)

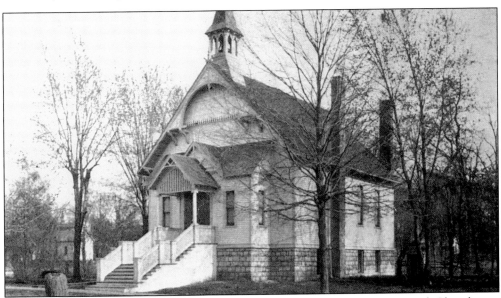

**FIRST CONGREGATIONAL CHURCH.** This first building of the Congregational Church was erected on Curtiss Street in1874. The first meetings had been held in Naperville as early as 1833. In 1837, the East DuPage church was organized and built a meetinghouse in 1845. After 20 years or so the membership split, and the First Congregational Church of Downers Grove was founded. In 1925, the present brick church was erected at the same location as the first building, with an addition built in 1964.

**AVERY COONLEY KINDERGARTEN.** This impressive building on Grove Street was the first kindergarten in Downers Grove in 1912.

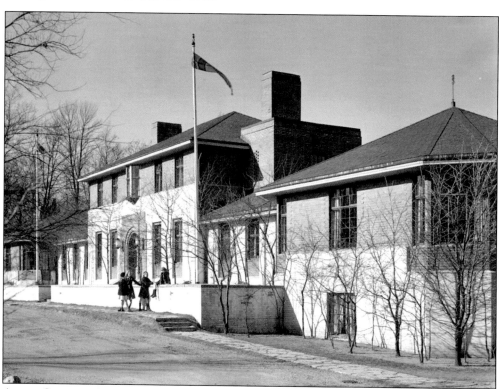

**AVERY COONLEY SCHOOL.** This shows the Avery Coonley School that was built in 1929 on an 11-acre campus. By 1933 there were students in all the grades from kindergarten through eighth grade. In 1993, a major expansion program added a library/learning facility, a gymnasium, additional teaching areas, a performing arts center, and other facilities.

**DOWNERS GROVE COMMUNITY HIGH SCHOOL.** Students walk along the path from the Prince Street entrance of the new community high school built in 1928.

**WHITTIER SCHOOL.** The third grade class of Whittier School lined up for their 1938-school picture. From left to right are: (first row) Carol Hillmar, unidentified, unidentified, Gordon Miller, Pat ?, Lawrence Stefens, Dick Hagley, unidentified, Donald ?, Bud Palmer, Maren R ?, and the teacher–Mrs. Salmore; (second row) Amelia Morgan, Leroy P ?, Howard Reed, Clarence ?, Edith King, Ray Genasky, BeBe Shopp, Janet Gordon, Alice Fairbanks, and Evelyn Van Kosten. (Photo courtesy of Bea Waring.)

**MIDWESTERN UNIVERSITY.** This dramatic bell tower is a focal point of the scenic 105-acre campus. (Photo courtesy of Midwestern University.)

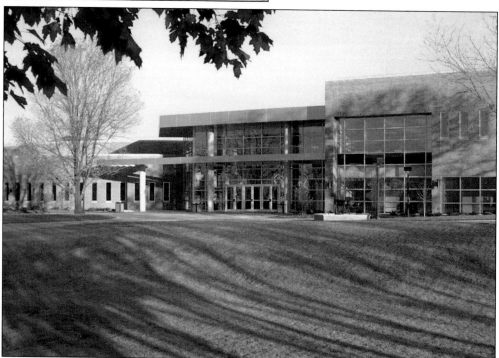

**MIDWESTERN UNIVERSITY.** This photograph shows the Library Technology Center, which was dedicated in August of 2001. This is one of the 16 academic buildings of the Midwestern University campus. (Photo courtesy of Midwestern University.)

**DOWNERS GROVE SOUTH HIGH SCHOOL.** This is the west end of the South High School building with the new addition of 2002. (Photo by M. Dunham.)

**DOWNERS GROVE SOUTH HIGH SCHOOL.** This photograph shows the south side and entrance of the high school including the new addition of 2002. (Photo by M. Dunham.)

**DOWNERS GROVE NORTH HIGH SCHOOL.** This is the new Main Street entrance of the addition to North High School in 2002. (Photo by M. Dunham.)

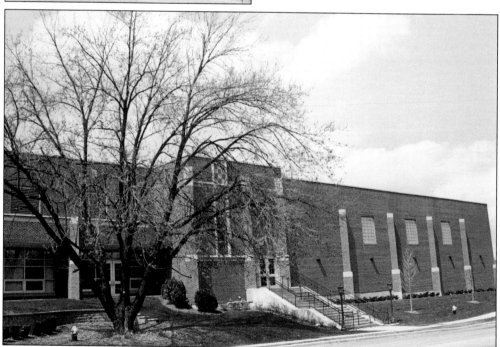

**DOWNERS GROVE NORTH HIGH SCHOOL.** Pictured is the new red brick addition extending north from the main entrance on Main Street. (Photo by M. Dunham.)

# *Eight*

# THE PARK DISTRICT AND LIBRARY

From the earliest days, the villagers of the Grove enjoyed their areas for picnicking and celebrations. The small ponds and bogs where young boys fished, and the fields and forests provided spaces and places for outdoor fun. Then through the years the Village acquired Grove Street Park (now Fishel Park), Randall Park, Gilbert Park, Littleford Park, and Prince Pond.

The Downers Grove Park District was created by a majority vote in a local referendum on June 15, 1946. The election of 1946 named five men to the non-salaried post of park commissioner, and Otto Hummer was voted chairman of the Board by his fellow commissioners. The Board of Commissioners, at that first meeting, voted to borrow $500 at two percent interest "to carry on the business of the District."

In 1948, the Village of Downers Grove deeded all of their parks to the newly created Park District with the exception of Grove Street Park, which was leased. The Downers Grove Park District then began its work with donated land.

Hummer resigned from the Board in 1962 to become the first superintendent of the Park District, and in the 1960s the Park District Commissioners voted to hire a few permanent part-time employees to carry on the business of the District.

The growth and services of the Downers Grove Park District in meeting the recreational and environmental needs of the residents of the Village of the Downers Park District has been phenomenal. The Park District hired its first recreation director in 1971, and the recreation program has grown from year to year to an amazing scope of offerings for people of all ages.

Through more than 50 years, the Park District has consistently sought to acquire and preserve open lands for recreational and environmental purposes. Often the Park District bought land at a time when it could ill afford the expenditure, in order to acquire land when it was available.

One of its very important purchases was the $725,000 purchase of the 86 acre Downers Grove Golf Course, which is one of the ten oldest golf clubs in the United States. The Park District bought the Lincoln School building in 1974, and after considerable remodeling, moved its Senior Center into the renovated building. In 1974, the Park District also entered into an agreement with the Downers Grove Historical Society to furnish a building to house the society's collection. After a couple of locations it was decided to buy the historic Blodgett home and the museum had its formal opening on January 30, 1977.

At the turn of the 21st century, the Downers Grove Park District owned approximately 600 acres for either recreational purposes, or environmental preservation and education. In 2003, the Downers Grove Park District has some 50 park sites and facilities located throughout the Village, providing a full range of recreational activities.

The Park District entered the 21st century with a series of challenges as the commissioners worked to meet the needs of the community, as they understood those needs. After hours of meetings and discussions and a non-binding referendum, the Park District went forward to build a magnificent new recreation center on Belmont Avenue near Ogden. Their plans for a swimming pool in conjunction with the recreation center were placed on hold for a later day when an appropriate site could be identified.

Throughout the years the residents of Downers Grove have enjoyed the resources and the facilities of the Downers Grove Public Library. It all began in 1891 when a small group of women collected books for a free circulating library, and L.P. Narramore donated a room in the Farmer's and Merchant's Bank to be used for the library reading room. In 1895, John Stanley constructed a small building on west Curtiss Street for the expanding library. This small group of women of the Library Association

worked with such dedication that John Oldfield left a bequest of $2,000 toward the purchase of a lot for a new library building. With the lot and the approval of a tax for the maintenance of a building, the Andrew Carnegie Fund agreed to provide funds for the library building.

In the fall of 1915, the handsome red brick Andrew Carnegie library building at the corner of Forest Avenue and Curtiss Street opened its doors to the public. For the next 40 years the library served the residents of the Village well, but by the early 1950s, with the growing population of the Village, it was clearly evident that the library needed to expand its services and its building. It was also clear that with the taxing demands of the schools and the other public agencies, passing a building referendum would be difficult.

Thanks to the commitment and determination of the Friends of the Library, the staff, and the Village, a $165,000 bond referendum was passed in December of 1954. As a result the "wraparound building" designed by local resident and architect George Steckmesser was opened to the public on July 1, 1956.

Over the following years the growth and pace of demand for services was incredible. The library became a part of the Suburban Library System and developed into one of the dominant libraries in the region under the leadership of the Library Board and the dedicated librarians.

The need for more adequate building facilities again became obvious. The decision was made to construct an entirely new building on the original site. The modern functional building, designed by John Wilson of Loebl, Schlossman Dart & Hackl, Associated Architects, was opened to the public in the fall of 1977. And then a final extensive addition, designed by Phillips Swager Associates, was completed and opened in February of 1999.

Today the Downers Grove Public Library can take pride in being one of the oldest and most active forces on the local cultural and educational scene in our village. The library has been served well by knowledgeable and committed staff members, the dedicated Board members and the involved Friends of the Library.

DOWNERS GROVE MUSEUM. This sign is in front of the Downers Grove Park District Museum at 831 Maple in the Victorian house built in 1892 by Charles Blodgett. The Museum Park was named Wandschneider Park in honor of historian Pauline Wandschneider, founder of the Downers Grove Historical Society and first curator of the Museum. (Photo by M. Dunham.)

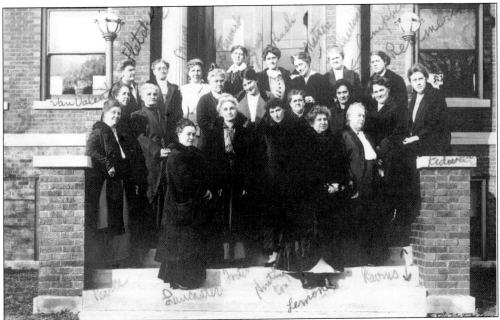

**LADIES' LIBRARY ASSOCIATION.** This photo was taken of the group of ladies who formed the Ladies' Library Association in 1891 as they saw a need for a library in the Village. The ladies are standing on the steps of the "new" red brick Downers Grove Library. This picture includes, but in no order, Mesdames John Stanley, Curtiss, Blanchard, Miller, Marsh, Clifford, Cole, Thomas, Narramore, Burns, Daniels, Atwood, Cross, Bunge, Downer, S.C. Stanley, Hughes, Diez, Northrup, Sacksetter, Lancaster, Huling. Stanger, and Miss Gertrude Gibbs.

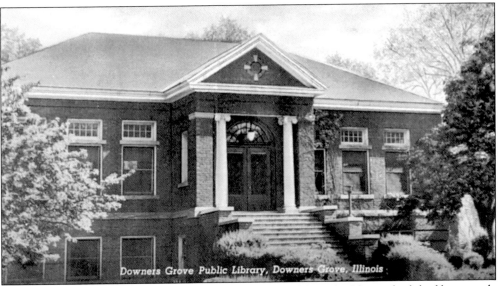

**THE CARNEGIE LIBRARY.** On October 15, 1915 the new library building, which had been made possible by a gift of building funds from Andrew Carnegie and the bequest of money from John Oldfield for the site, was officially opened to the public This splendid library building was a tribute to the dedication and determination of the Ladies' Library Association as they worked so hard to gain a library for the Village.

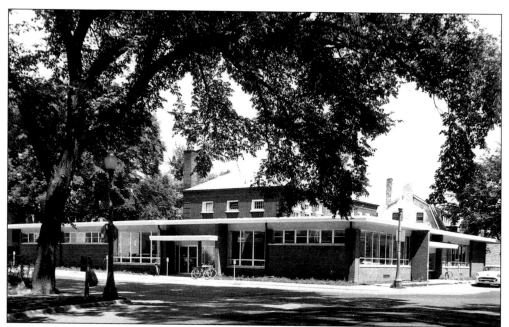

**WRAPAROUND BUILDING.** This picture shows the Downers Grove Public Library with its wraparound addition, which was opened to the public in July 1956. With the critical need for more space, a vigorous effort by the Friends of the Library, the staff, and the Village was successful in passing the referendum for the necessary funds. The addition was designed by local architect George Steckmesser as an innovative expansion of the original building to 'wrap around' the red brick library building.

**MODERN LIBRARY BUILDING OF 1977.** Again the active public library in the growing Village outgrew its space, and this time the decision was made to take down the old buildings and build a totally new modern facility. Interesting that with the succession of three buildings, the library never changed its location. This building was designed by John Wilson of Loebl, Schlossman, Dart and Hackl-Associated Architects.

**ADDITION OF 1999.** This photo shows the main entrance on Curtiss of the completed new addition, which was opened to the public in February 1999. (Photo by M. Dunham.)

**ADDITION OF 1999.** This picture was taken toward the east along Curtiss as the building extends toward Forest Avenue. (Photo by M. Dunham.)

**SCULPTURE.** This graceful bronze sculpture, entitled "Children of Peace," stands on the Garden Walk, at the southwest corner of the building. Gary Price, the sculptor, describes, "In this sculpture, the children's bodies form simple arches. Arches are the beginning of circles and circles are simple and beautiful forms that represent peace, harmony, and eternity." (Photo by M. Dunham.)

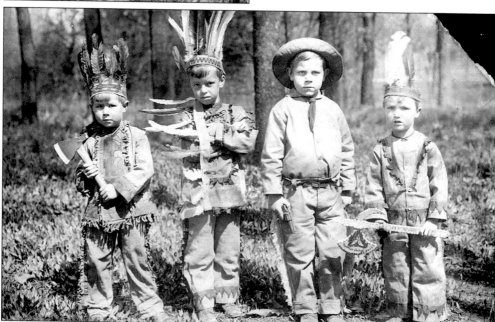

**LITTLE INDIAN BOYS.** This picture was taken before a park district was created and all the woods were their playground. These three little Indians and one cowboy were very serious about their play in the woods. They are, from left to right, Crescy Woehrel, Gardiner Barr, Donald Drew, and William Kuntemeyer.

BELMONT GOLF COURSE. The nine-hole golf course was laid out in 1893 on 60 acres of land owned by A. Haddow Smith at Belmont near the CB&Q Railroad. Smith's chief assistant was a hired man with a shovel, rake, and wheelbarrow. Since no regulation cups were available, tin cups were used. This was the first nine-hole golf course west of the Appalachians.

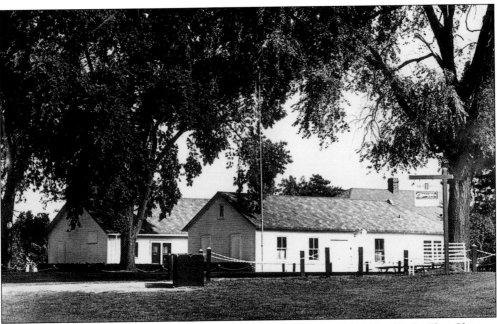

GOLF COURSE. This picture shows the old original clubhouse (1893–1976). The Chicago Golf Club was organized in Smith's home on the course. Members of the Chicago Golf Club included J.C. Sterling, J. Marshall Weir, James Forgan, Charles B. McDonald, Arthur Ryerson, and Robert Todd Lincoln. On December 22, 1894 the Chicago Golf Club became one of the five founding members of the United States Golf Association. Robert Todd Lincoln, son of Abraham Lincoln, served as the ninth president of the Chicago Golf Club.

**LINCOLN CENTER.** This building, which was massively remodeled, is the center for many Park District programs, from the Senior Center with its many activities and lunch program, to extensive programming for children. The Breasted Auditorium is dedicated to the memory of Dr. James Henry Breasted, and is home to many programs and organizations. (Photo courtesy of the D.G. Park District.)

**PLAYGROUND.** These children are enjoying playing in one of many Downers Park District play areas for children. (Photo courtesy of the D. G. Park District.)

**MIKE TROY.** A happy winner, Mike Troy is pictured holding his trophy as the winner of the Pine Hollow Open. Troy shot 3 under par 33 at the historic Downers Grove Golf Course to capture the 26th annual championship. (Photo courtesy of Bruce Swanson.)

**DOWNERS GROVE PARK DISTRICT GOLF CLUBHOUSE.** This is a view of the gently rolling golf course with the present day clubhouse in the background. The course is situated on 60 acres of the total 90 acre facility. Par is 36. (Photo courtesy of the D. G. Park District.)

**PINE HOLLOW OPEN GOLF TOURNAMENT.** Playing a round of golf during the Pine Hollow Open are, from left to right, Downers Grove Village Manager Rick Ginex, Bruce Swanson, Mayor Brian Krajewski, and Barb Wysocki, director of the Downers Grove Area Chamber of Commerce and Industry. Pine Hollow Open is held at the Downers Grove Golf Club. (Photo courtesy of Bruce Swanson.)

**DOWNERS GROVE PARK DISTRICT RECREATION AND FITNESS CENTER.** This is the entrance to the Recreation and Fitness Center, which was recently completed and is now open to the public. This facility is located on the west side of Belmont Road just south of Ogden Avenue. (Photo courtesy of the D.G. Park District.)

# Nine

# THE POLICE AND FIRE DEPARTMENTS

In 1885, Gardner Paige was the police magistrate and Valentine Wetten was the policeman. The task of keeping law and order in this small village was not difficult. The frame Village Hall on Main Street near St. Joseph's Creek had one large room for the Village Hall and two jail cells. A desk, in one corner of the large room, was the "police station." Usually the only occupants of the jail cells were the occasional 'inebriates' who needed a place to sleep. It did get a little confusing when the Village Board met, and the occupants of the cells would quarrel with the decisions of the commissioners.

By 1893 it seemed necessary to hire a night policeman who was paid $25 a month and "such private subscriptions as were approved by the board." His job duties included keeping the Village Hall and the jail clean, building the fires in the Village Hall, and to have charge of all the persons confined in the jail during his hours of duty. He was also responsible for the street lamps, was expected to patrol the streets, and to meet the late incoming trains.

By 1917 the day policeman was Martin White and the night policeman was John Stockenbery. Foot patrols were the order of business for police officers in this small village. In 1925, the Police Department moved to the second floor of the newly constructed Memorial Village Hall.

An eight-box call system was installed in 1931. The officer, walking his beat, could keep in touch with the station by calling in at regular intervals from the telephone boxes. The villagers were impressed with the efficiency of the system. In addition, there was another method of communication. When a yellow light flashed atop the water tower, it meant that the beat cop had better get to a telephone fast. It likely meant that his superior officer needed to talk to him.

Mike Venard was police chief for many years and continued on the force when he was replaced as Chief by Walter Otto on December 31, 1931. In 1939, the Police Department acquired two-way radio equipment. The Downers Grove Reporter described the marvelous advantage of the equipment in that calls from the police headquarters could be received with ease all over the Village.

In 1952, the department had two squad cars, one for the north side of town and one for the south side. That same year the reserve police were organized. Otto Springborn was police chief when the Police Department moved to a new building at 945 Burlington in 1958. The Police Department shared this building with several other Village departments. Then in July of 1979 the Police Department moved to the splendid new Police Department Building at 825 Burlington in the Civic Center, which is their present location in 2003.

Police Chief Robert Porter is legally mandated to manage the Downers Grove Police Department. He reports directly to Village Manager Riccardo Ginex as do the Fire Chief and the Public Works Director. The Downers Grove Police Department consists of two major bureaus, operations, and administration. A deputy chief, who reports directly to Chief Porter, commands each bureau. The Operations Bureau includes patrol, investigations, and SWAT. The department has 81 sworn and 35 non-sworn personnel. At the turn of the 21st century the Downers Grove Police Department has state-of-the-art facilities and technology in providing excellent police services to the Village.

The Downers Grove Fire Department was founded over 100 years ago as a volunteer department. Through many years, an ongoing group of dedicated volunteers worked side by side with full-time firefighters until the fire department finally consisted of all professional full-time firefighters. In the early days, a fire struck panic in the heart of every householder. Friends and neighbors rallied to fight any fire, but in addition there was a group of about 20 men who always helped. These volunteers would form a bucket brigade, passing dripping buckets one to another to empty on the flames and then recycle the buckets to be refilled.

In 1885, the Village purchased 500 feet of hose and a hand pumper, which pumped water from wells

and cisterns. This vastly improved pumping system replaced the bucket brigade. However, every well and cistern in the neighborhood was pumped dry when a fire of enormous proportions burned out of control in 1893. It became clear there needed to be a better source for water.

That next year, the voters approved the sale of bonds for a waterworks system. A water tower was built on Summit Street between Lane Place and Main Street on land purchased from Marshall Field and a brick pumping station was built on Belmont (now Warren Avenue). With the new waterworks, firefighting in the Village was greatly improved.

In 1895, 30 some men met in the Village Hall to form two fire companies, one for the north side of the railroad tracks and the other for the south side of the tracks. The first Volunteer Fire Department was organized in 1898 and incorporated in 1904. The year 1906 was a memorable year for the department when it acquired a 1,100 lb. bell for sounding alarms, and a badge was selected to be worn by all the department members. The most far-reaching event of that year though, was the fire at the Dicke Tool Company, which destroyed all the company's buildings.

Out of this misfortune came the dedication of Casper Dicke's seven sons to firefighting in the Village. The name of Dicke is almost synonymous with the Village Fire Department. Grant Dicke served 50 years in the department and as fire chief from 1924–1967. Henry Dicke was fire chief from 1914 to 1924 and Elmer Dicke served as assistant fire chief for many years. Frank Wander was named the first full-time fire chief on January 1, 1967, and when he retired, his son John succeeded him as chief.

For many years, the structure and spirit of the Downers Grove Fire Department was unique with the combination of full-time fire fighters and volunteers. Every full-time firefighter was by choice a paid-on-call volunteer. All of the firefighters were members of the Downers Grove Volunteer Fire Department, Inc., a social and professional service club. Many of the firefighters had been volunteers for 30–35 years.

The present day Downers Grove Fire Department is one of the most respected departments in the state. Phil Ruscetti is the fire chief and James Jackson and Robert Tutko are deputy chiefs. The department has 15 Lieutenants, 44 Paramedics, and 18 firefighters who work out of 4 fire stations: Station #1 at Wisconsin and Katrine, Station #2 at Main and Summit, Station #3 at Thirty-ninth and Highland, and Station #5 at 6700 Main Street adjacent to McCollum Park. Station #4, which was at the base of the water tower on Findley Road, was closed in 1992.

A new 100-foot ladder truck arrived just in time for the department's centennial celebration in 1998. In 2000, the department upgraded to two new state-of-the-art ambulances, and a new Pierce Rescue Pumper was put into service at station 5. This vehicle functions as a structural pumper and HazMat Team vehicle. And then in the spring of 2002 the department obtained a new squad, which has been showcased in various areas of the state as a multi-faceted heavy rescue vehicle. The Downers Grove Fire Department is a modern progressive department, which provides a full range of emergency services to the residents of our village.

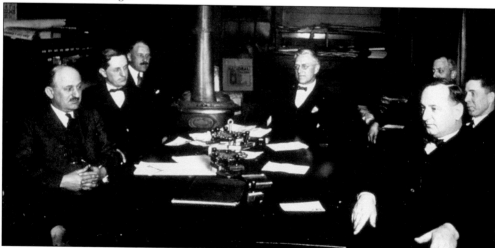

**VILLAGE COUNCIL 1919–1923.** Shown is the Village Board meeting in the Village Hall with its one large room and two jail cells. The "Police Station" was a desk in the corner of the meeting room. Pictured from, left to right, are C.M. Davis, W. Bender, I.G. Heartt, Charles Hitch (village clerk), Mayor W.C. Barber, Delbert Austin, King Bush, and Charles Haller.

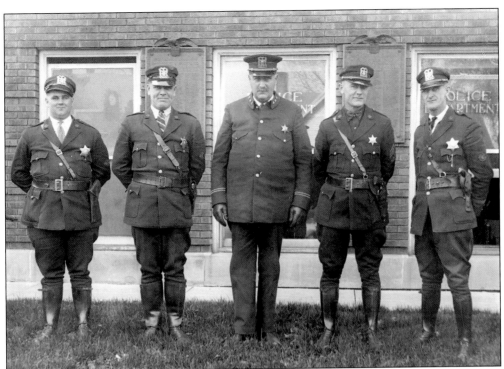

**DOWNERS GROVE POLICE–1925.** This photograph shows the Downers Grove Police force in 1925. Pictured from left to right are unidentified, Edward Russo, Mike Venard, William Conway, and Paul Tussy. Mike Venard was police chief for many years and continued on the force when he was replaced as chief by Walter Otto on December 31, 1931.

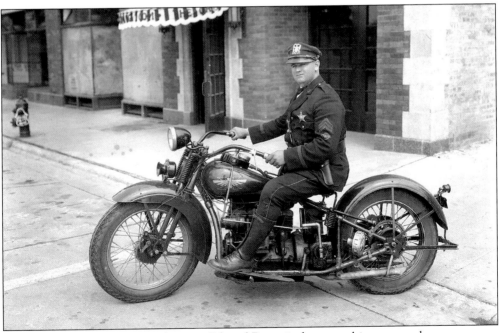

**MOTORCYCLE POLICEMAN.** Policeman Edward Russo is shown on his motorcycle.

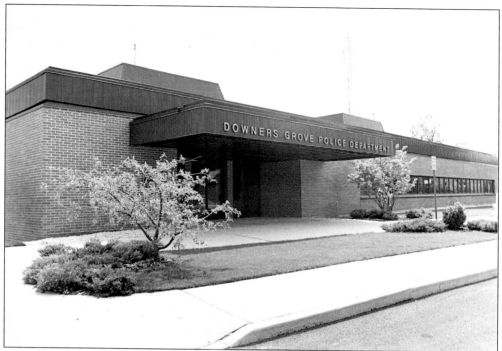

**POLICE DEPARTMENT BUILDING.** Pictured is the 'new' Downers Grove Police Department Building at 825 Burlington in the Civic Center. The Police Department moved to this building in July 1979 and it is their present location in 2003. (Photo courtesy of the D.G. Police Dept.)

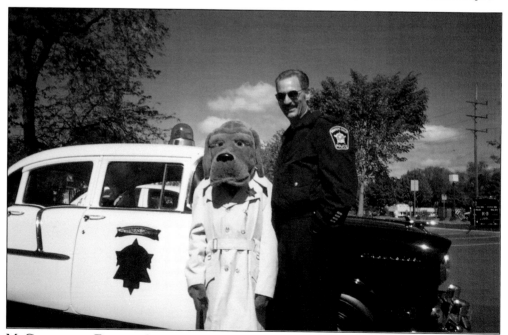

**McGRUFF AND FRIEND.** Crime Dog McGruff is standing with then-Police Chief Riccardo Ginex (and now Downers Grove Village Manager) beside the vintage 1955 Ford squad car. (Photo courtesy of the D.G. Police Dept.)

ROLL CALL. At roll call, the oncoming shift of the Downers Grove Police Department is listening intently to the information being given them by the sergeant. Patrol officers work eight-hour shifts while patrol sergeants work ten-hour shifts. The department has 81 sworn and 35 non-sworn personnel. (Photo courtesy of the D.G. Police Dept.)

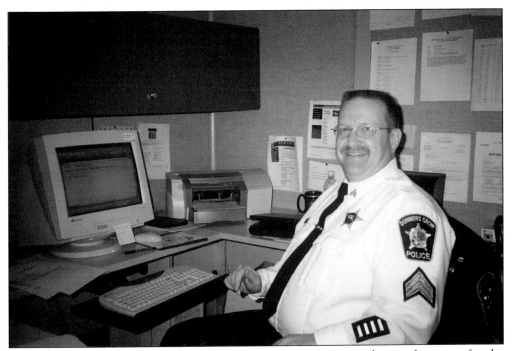

AT THE COMPUTER. Shown is Sgt. Ken Groce, the sergeant in charge of training for the department, at his desk. (Photo courtesy of the D.G. Police Dept.)

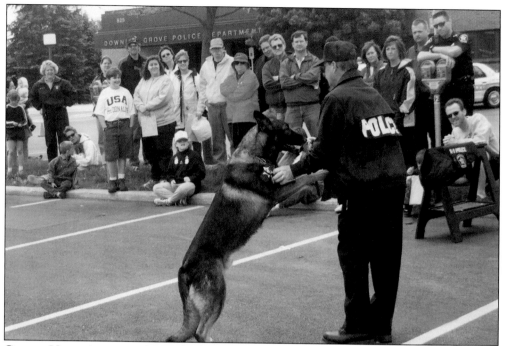

**CANINE UNIT.** At an open house for the public, Canine Officer Kurt Heinrich is demonstrating the capabilities and training of this police dog, "K-9 Passo." Among the spectators is Mayor Brian Krajewski who is standing with folded arms directly in back of Passo and Officer Heinrich. (Photo courtesy of the D.G. Police Dept.)

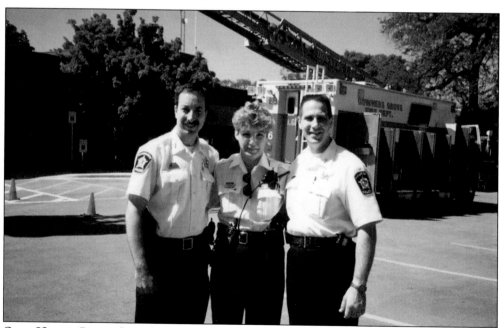

**OPEN HOUSE.** Pictured are, from left to right, Police Chief Robert Porter, Marcia Heintz (crime prevention specialist), and Kurt Bluder (deputy chief of operations). In the background is a Fire Department ladder truck. (Photo courtesy of the D.G. Police Dept.)

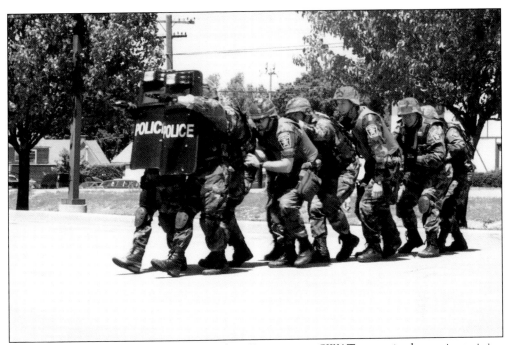

**SWAT TEAM.** The Downers Grove Police Department SWAT team is shown in training exercises. (Photo courtesy of the D.G. Police Dept.)

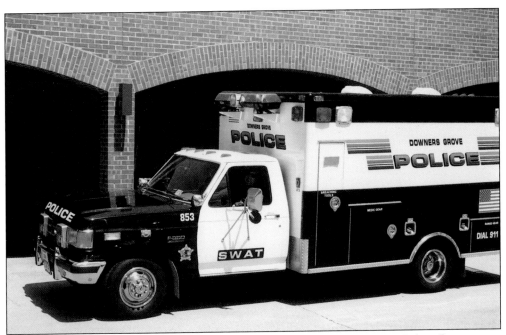

**SWAT TEAM.** This truck is specially equipped for the Downers Grove Police Department SWAT team. (Photo courtesy of the D.G. Police Dept.)

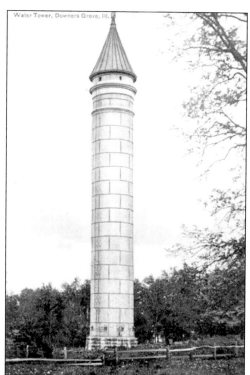

**WATER TOWER.** The water tower was built on Summit Street on land purchased from Marshall Field for $250. The location for the tower was the highest point for miles. The tower was 90 feet tall, 16 feet in diameter, and had a capacity of 135,368 gallons. This giant column of water maintained water pressure for the Village.

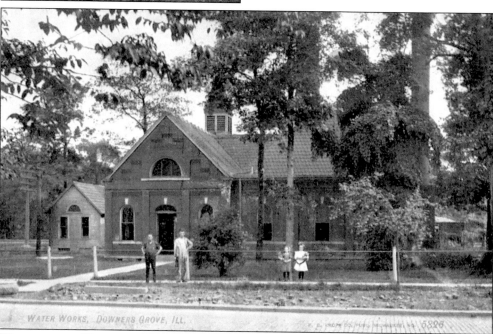

**WATERWORKS.** The greatest improvement for firefighting in the Village came with the new waterworks system. This pictures the municipally-owned pumping station, which was erected on Belmont Avenue (now Warren). Seven miles of pipeline were installed and two wells furnished water to the Village. An editorial in the March 22, 1895 Downers Grove Reporter said, "We now have as fine a system of waterworks as any village could wish."

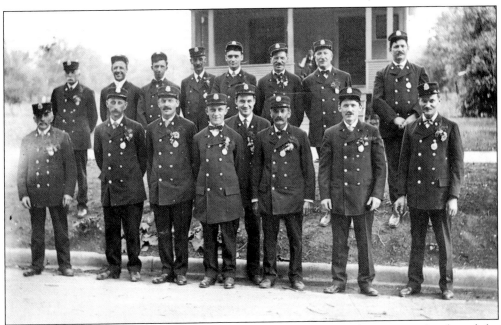

VOLUNTEER FIREMEN. This picture was taken of the volunteer firemen on the day of the Memorial Day Parade in 1911. From left to right are: (front row) Phil Binder, Florence Leibundguth, George Cline, Frank Konzak, Henry Dicke, Fred Binder, and Phil Mochel; (back row) George Binder, Add "Buck" Baker, Harry Darnley, Sam Hoffert, Phil Vix, Chris Staats, Louis Klein, and Val Wander.

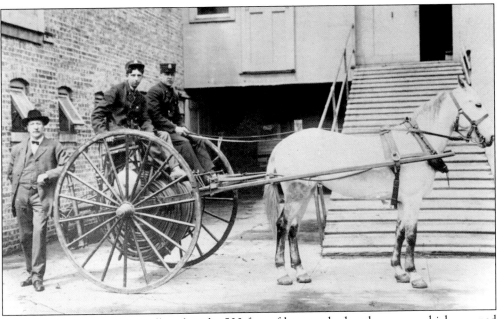

HOSE CART. In 1885, the Village bought 500 feet of hose and a hand pumper, which pumped water from the wells and cisterns. Since a team of horses was needed to pull the cart to the fire, the Village would pay $5 to $10 to the first man who brought a team for the hose cart when the alarm was sounded. This picture was taken in 1912 in front of the building at 1041 Burlington.

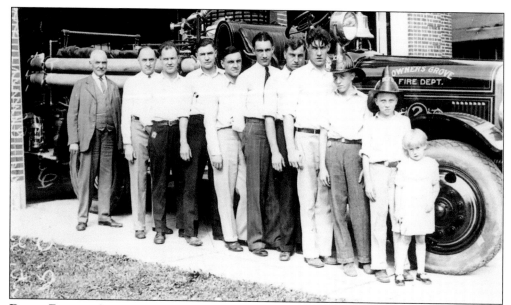

**DICKE FAMILY.** Casper Dicke is shown here with his seven sons and three grandchildren, standing by a fire truck in front of the original Firehouse #1 on Warren. Pictured, from left to right, are Casper Dicke, Henry C. Dicke, Chief Grant Dicke, Captain George Dicke, Asst. Chief Elmer H. Dicke, Captain Clarence Dicke, Arthur Dicke, Leonard Dicke, Robert Dicke, Donald Dicke, and Eleanor Dicke. As a result of the disastrous fires suffered by Casper Dicke's Tool Company, the Dicke family was dedicated and committed to firefighting in the Village.

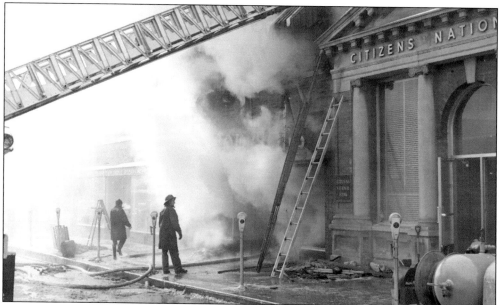

**FIRE ON MAIN STREET.** On December 22, 1960 one of the most damaging fires in the Village began in the basement of Thompson's Men's Store at 5112 Main Street and quickly spread to the Citizen's National Bank, the building immediately north of Thompson's. Downers Grove firemen, with the help of four other departments, battled the blaze for nine hours in temperatures reaching 12 degrees below zero!

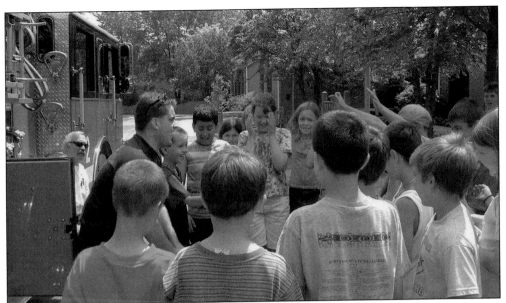

EDUCATION PROGRAM. The department is known for its progressive and innovative special teams, the Fire Academy, and active participation in many community programs. Educational Programs are presented throughout the schools. The students here are gathered around this professional firefighter seeking answers to their many questions. (Photo courtesy of the D.G. Fire Dept.)

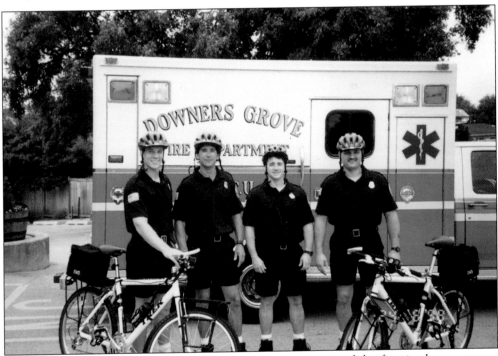

BIKE MEDICS. The Downers Grove Fire Department was one of the first in the country to assemble a successful bike medic program which has served as a first responder at Heritage Festival, the annual Bike Criterions, and several other Village functions. (Photo courtesy of the D.G. Fire Dept.)

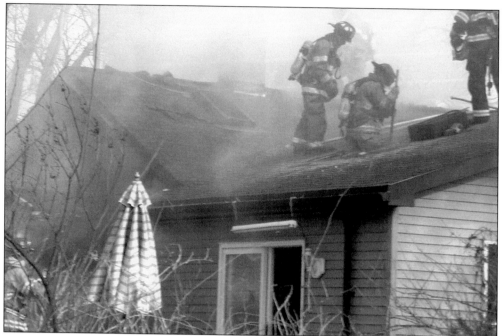

**HOUSE FIRE.** Battling the blaze of a burning house requires all the knowledge and efforts of these professional firefighters. (Photo courtesy of the D.G. Fire Dept.)

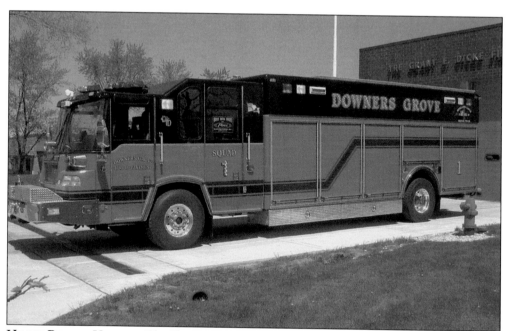

**HEAVY RESCUE VEHICLE.** The Downers Grove Fire Department obtained a new squad in the spring of 2002. This vehicle has been showcased in various areas of the state as a multi-faceted heavy vehicle that is used in Downers Grove, as well as for other local municipalities' mutual aid calls. This vehicle will respond state-wide if called upon for major disasters. (Photo courtesy of the D.G. Fire Dept.).

# Ten

# HISTORIC SITES

The sites and scenes of history can still be viewed in Downers Grove. There are three honorary historic districts in the Grove, which have been designated by the Downers Grove Historical Society. The Maple Avenue Honorary Historic District includes Maple Avenue from Main Street on the west to the Burlington tracks on the east. Maple was the first main street in the Grove and stemmed from an Indian trail, which was diverted by Israel Blodgett and Samuel Curtiss to run between their properties. They selected healthy young maple trees from the neighboring groves and planted them in even rows along their new roadway. Tall straight maple trees still line Maple Avenue.

The Main Street Honorary Historic District includes Main Street, from Maple north to the tracks, which was cut through with the coming of the CB&Q during the Civil War.

The Honorary Historic District of the E.H. Prince subdivision encompasses 225 acres from approximately Ogden on the north, the Burlington Northern Railroad tracks on the south to Highland Avenue on the east and Montgomery/Oakwood on the west. A drive or walk through the third Honorary Historic District of the E.H. Prince subdivision reveals a network of brick streets lined with gracious Victorian homes.

Each year since 1997 the Downers Grove Historical Society has designated a site of particular historic significance with a descriptive plaque. These sites include the Main Street Cemetery, the resting place of many of the early settlers of Downers Grove, and unique in its location on Main Street in the central business district; the Main Street Railroad Station at the site of the tragic 1947 Wreck Of The Zephyr speeding toward Chicago when it hit a tractor fallen from an east bound freight train; Prince Pond, the centerpiece of the E.H. Prince subdivision; Lincoln School, the early two-room school in Downers Grove, at the location of the present day Lincoln Center; the Belmont Golf Course, which was the first nine-hole golf course west of the Alleghenies, and the Tivoli Theatre, which celebrates its 75th anniversary this year in 2003, the second theatre in the United States to be designed and built for talking pictures.

Of the many homes of historical significance in Downers Grove the following homes have been documented as being 100 years old or older:

*Prior to 1994 wood plaques were given by the Downers Grove Historical Society to:*

Carpenter Home, (First Post Office and General Store), 1047 Maple Avenue *c.* 1843

Mochel & Son Hardware Store, 5122 Main Street *c.* 1884, (Closed 1995)

Israel Blodgett House (2nd), 812 Randall (Moved from 831 Maple *c.* 1892), Built *c.* 1849

Sucher Blacksmith Shop, Maple Avenue and Main Street, *c.* 1875 (Massively Remodeled)

First Baptist Church, (White Frame Building), Maple & Washington *c.* 1872
4807 Prince Street, *c.* 1869

First Congregational Church (Site), 1025 Curtiss Street, Original Building *c.* 1874, (Replaced By Current Building)
4816 Linscott, *c.* 1891

Downers Grove Park District Museum, Original Owner: Charles Blodgett, 831 Maple Avenue. *c.* 1892

"The Pines," Boyhood Home of James Henry Breasted, 4629 Highland, *c.* 1874

David Kline House, 1741 Prairie *c.*1858

From 1994 forward, the Centennial Homes Plaque Committee has officially acknowledged these documented centennial homes:

The Sterling North House
5228 Fairmount c. 1892

The Tillie Kinney House
4617 Forest c. 1890

The W. B. Towsley House
4730 Prince Street c. 1893

The Mcvean House
5152 Benton c. 1895

The John Oldfield Home
5226 Carpenter c. 1893

Lewis P. Sucher House
1220 Warren c. 1895

The Farrar House c. 1894
4811 Linscott

4836 Linscott c. 1894:
(Built on spec by Earl Prince)
c. 1891

The William M. Carpenter House
853 Maple Avenue c. 1894

The Frank J. Gorman House
1205 Franklin Street c. 1894

The Sebastian Schwer House
1218 Ross Court c. 1890

The Joseph Staiger House
4824 Saratoga Avenue c. 1897

The Ross S. Johnson House
4502 Prince Street c. 1896

Barn Castle
932 Prairie Avenue c. 1867

Edward Hanson House
4641 Saratoga Avenue c. 1894

The Straube House c. 1894
731 Maple Avenue

Conrad Penner Harness Shop
5219-5221 Main Street c. 1892

Emily Gilbert Lathrop House
1216 Gilbert c. 1890

William L. Singleterry House
5317 Webster c. 1903

Lottie McDougall House
4709 Linscott c. 1894

Another group of homes which are of significant historical interest are the homes which were built from the mail order house kits. There are said to be in excess of 250 of these homes in Downers Grove. The best known of these mail order kit homes, of course, were the Sears Homes. In the beginning these house kits were listed in the regular Sears catalog, but then as they grew in popularity individual catalogs for the some 450 styles of homes were published. The prospective buyer could select the model of his choice and then choose from the many options of the various features, including the type of wood to be used for the woodwork. In fact, the homebuilder could individualize his own kit home to the needs and preferences of his own family.

Approximately 70 of the Sears homes have been positively identified in Downers Grove, and many more of the kit homes have yet to be identified. The Downers Grove Visitors Bureau has a brochure identifying the location of some 25 of the Sears Catalog homes in the Village which can be viewed on a walking or driving tour. It is said that Downers Grove is among the villages having the most Sears homes.

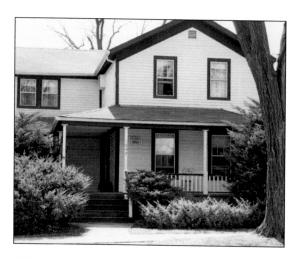

**HENRY CARPENTER HOME.** Henry Carpenter built this house in about 1845. He was the postmaster so this house served as the first post office in Downers Grove and also as a general store. In 1976, during the Bicentennial Celebration, the 200th birthday of our nation, a "General Store and Post Office" was opened in the Carpenter house. This was a project of the Downers Grove Junior Women's Club assisted by the Downers Grove Historical Society. This house is still a residence at the corner of Maple and Lane Place. (Photo by M. Dunham.)

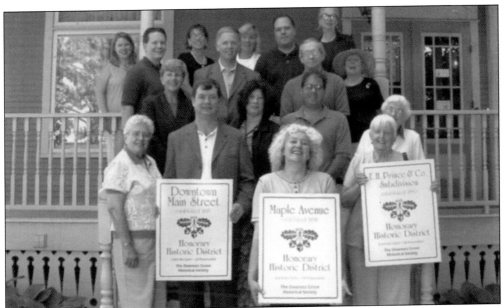

**HONORARY HISTORIC DISTRICTS.** This picture was taken on September 8, 2001 at the announcement of the designation of three honorary historic districts in Downers Grove: Main Street, Maple Avenue, and the E.H. Prince Subdivision by the Downers Grove Historical Society. The group includes the Preservation Committee of the Downers Grove Historical Society, members of the Downers Grove Village Council, and members of the Downers Grove Historical Society Board. In the front row, second from left is Mayor Brian Krajewski holding the sign designating the Main Street Historic District. (Photo by P. Betenia.)

**THE PIERCE DOWNER HOUSE.** This is probably the oldest existing house in the Village, built by Pierce Downer in 1842 on the site of his original log cabin. This house is located at 4437 Seeley and is noticeably not parallel with the street. Seeley Street was laid out long after the house was built, and runs between the house and the Downer well, which is on the west side of the street.

**THE W.B. TOWSLEY HOME.** This Centennial Home is located at 4730 Prince Street in the E.H. Prince Subdivision and was built about 1893. The present owners are David and Robin Rutkowski. (Photo by Frank Betenia.)

**THE EDWARD HANSON HOUSE.** This picture shows the home at 4641 Saratoga as it looks today. This Centennial Home has been handsomely restored both inside and out. Note the veranda with the intricate decorative fretwork. The present owners are Greg and Sandy Evans. (Photo by P. Betenia.)

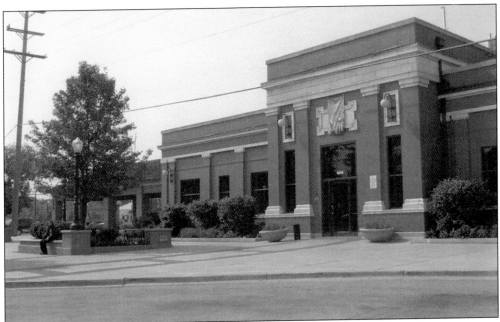

DOWNERS GROVE TRAIN STATION. This is the new, recently modernized Main Street train station in Downers Grove. The plaque commemorating the Zephyr Train Wreck is affixed to this building. (Photo by Phyllis Betenia.)

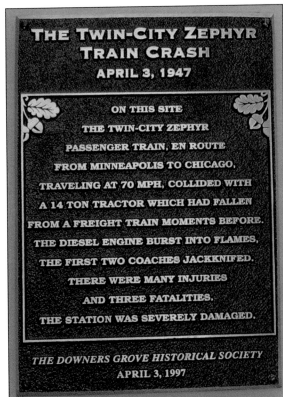

THE TWIN-CITY ZEPHYR
TRAIN CRASH
APRIL 3, 1947

ON THIS SITE
THE TWIN-CITY ZEPHYR
PASSENGER TRAIN, EN ROUTE
FROM MINNEAPOLIS TO CHICAGO,
TRAVELING AT 70 MPH, COLLIDED WITH
A 14 TON TRACTOR WHICH HAD FALLEN
FROM A FREIGHT TRAIN MOMENTS BEFORE.
THE DIESEL ENGINE BURST INTO FLAMES,
THE FIRST TWO COACHES JACKKNIFED.
THERE WERE MANY INJURIES
AND THREE FATALITIES.
THE STATION WAS SEVERELY DAMAGED.

THE DOWNERS GROVE HISTORICAL SOCIETY
APRIL 3, 1997

THE TWIN-CITY ZEPHYR TRAIN CRASH. This plaque was placed on the railroad station by the Downers Grove Historical Society on the 50th anniversary of the tragic train crash of April 3, 1947. (Photo by P. Betenia.)

**GOLF COURSE RECOGNITION.** This pictures shows, from left to right, Downers Grove Historical Society board member Mary McNamara, 1999 president of the Downers Grove Historical Society Bob Arehart, and Park District board commissioner Bud Sherman. Arehart is holding the plaque commemorating the Belmont Golf Course, which was presented to Bud Sherman for the Downers Grove Park District. The Belmont Golf course was opened in 1893, the first nine-hole golf course west of the Appalachians. (Photo by Phyllis Betenia.)

**THE PINES.** This picture shows the boyhood home of famed Egyptologist Dr. James Henry Breasted. The family moved to Downers Grove in 1873 when James was eight years old, and his father built this house the following year in 1874. Years later the Nourse family lived here. Their two daughters, Alice Nourse Tisdale Hobart and Mary became well known authors, and their son, Edwin, became president of Brookings Institute of Washington D.C. (Photo by P. Betenia.)

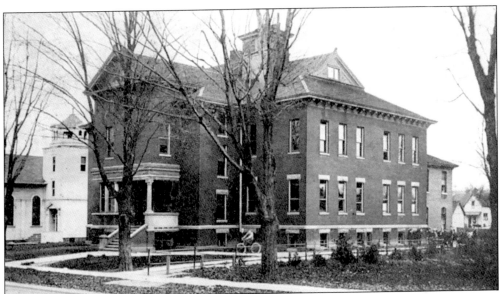

LINCOLN SCHOOL. A brick two-room school was built in 1867 at this location. It later became Lincoln School. Two additional rooms were added in 1876 and the first high school students graduated in 1879. The northern section was added in 1900 to the front of the four-room building. The Downers Grove Historical Society recognized historic Lincoln School with a plaque in 2001.

MAIN STREET CEMETERY. The Downers Grove Historical Society commemorated the cemetery with a plaque in December of 2000. The plaque reads: "In 1856, Samuel Curtiss donated part of his sheep pasture for use as a cemetery. He was later paid $15 for the land, money from individuals who formed a cemetery association in 1864. Nearly 100 members of Downers Grove early families, including Israel Blackburn, a freedman, and members of the Blanchard, Curtiss and Wells families are buried here. The cemetery was used until 1939 when Emma Foster Miller was the last to be interred. It is one of the few American cemeteries located in a main business district." (Photo by P. Betenia.)

**SEARS HOME.** This Sears Home is located at 1340 Gilbert. One of the largest of the Sears Kit Homes, it is the model named the Lexington and is unusual in that it has two sun porches, one at each end of the house. This home was bought in 1920 but not completed until 1925. The present owners are Lorie and Tom Annarella. (Photo by M. Dunham.)

**LIVING ROOM.** The interior of this Lexington home has beautiful dark woodwork with a lovely curving staircase to a large landing. There are many French doors throughout the first floor. The large brick fireplace is the focal point in the living room. Note the rich cove molding at the ceiling. (Photo by M. Dunham.)

**SEARS HOME.** This picture shows, from left to right, Ernie Smith, Kay Smith, and Bob Jensen on the front stoop of the Smith's Sears home at 5636 Dunham. This home was a combination of two Sears house kits, the Van Dorn, which was then expanded to a Van Jean. The house was built in 1929. Bob Jensen is a worldwide authority on Sears, Roebuck catalog homes. In May of 2000, Jensen's work in identifying Sears Homes in Downers Grove received national recognition when it was officially entered into the Library of Congress as one of America's Local Legacies. (Photo by M. Dunham.)

**SEARS CATALOG HOMES.** This brochure presents a map and identification of Sears Homes in Downers Grove for a Self-Guided Walking/Driving Tour. (Courtesy of the D.G. Visitor's Bureau.)

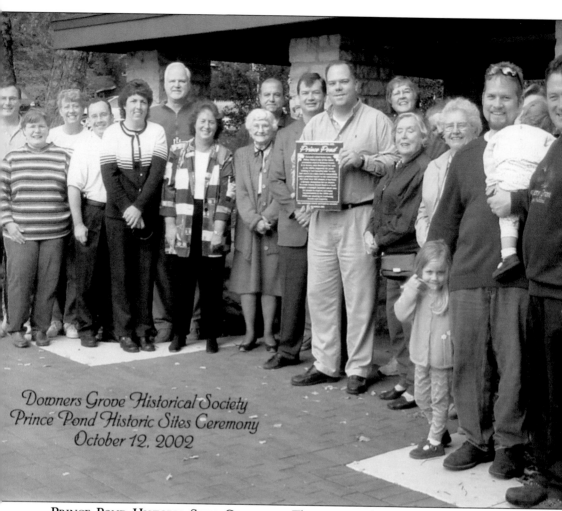

Downers Grove Historical Society
Prince Pond Historic Sites Ceremony
October 12, 2002

PRINCE POND HISTORIC SITES CEREMONY. This pictures the presentation on October 12, 2002 of the commemorative plaque for the Prince Pond Historic Site to the Commissioners of the Downers Grove Park District. In the middle of the picture, Greg Evans, president of the Downers Grove Historical Society, is holding the plaque and immediately to his right is Mayor Brian Krajewski. The others in the picture include the members of the Downers Grove Park District Board of Commissioners, members of the Board of Directors of the Downers Grove Historical Society, Commissioners of the Downers Grove Village Council and residents of the Prince Pond area. (Photo by P. Betenia.)

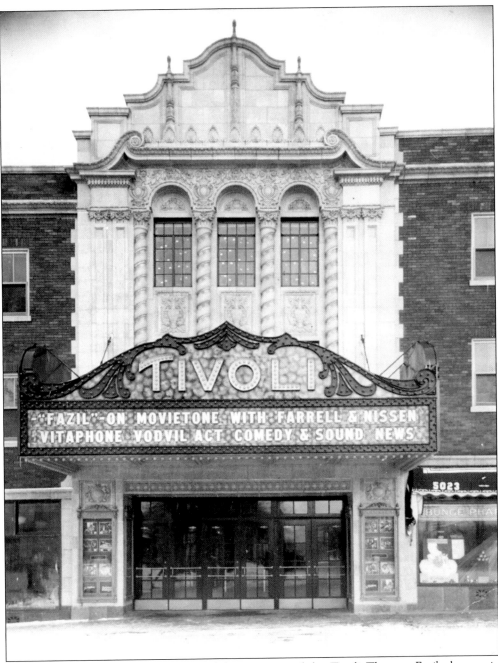

**TIVOLI THEATRE.** This is a close up of the entrance of the Tivoli Theater. *Fazil*, the movie advertised on the marquee, was the first Movietone movie shown at the Tivoli. The Roxy orchestra of the Roxy Theatre in New York City played the original score. The musical reproduction was said to be very successful. The terra-cotta front of the theater was illuminated at night by several floodlights, which made a very dramatic display.

**BOARD OF DIRECTORS OF THE DOWNERS GROVE HISTORICAL SOCIETY.** From left to right are: (front row) Joan Read, Mary McNamara, Evelyn Poulin, and Katie Blanchard; (back row) Montrew Dunham, Phyllis Betenia, Greg Evans (President of the Board), and Frank Betenia. Not pictured is Jane Pugh. (Photo by Sandy Evans.)

The Downers Grove Historical Society was founded on May 16, 1968 when a group of women gathered at the home of Mrs. Roger Goding for the purpose of studying and researching the history of their town. Among them were Mrs. Roger Goding, Pauline Wandschneider, Grace Brown, Shirley Sulllivan, Mrs. William Antonoff Jr., Mrs. Louis Verveer, and Miss Lucile Bush. Since that time, the Downers Grove Historical Society has worked diligently and with enthusiasm to fulfill its mission to "preserve the history of the Downers Grove area and thus help present and future generations to better understand the past."

The Downers Grove Historical Society is a non-profit, volunteer organization whose funding comes from memberships, donations, and grants. A Board of Directors is elected by the membership.

One of the Society's more important contributions was the establishment of the Downers Grove Historic Museum in conjunction with the Downers Grove Park District, largely through the efforts of Pauline Wandschneider. Another of the society's major contributions is its role as consultant to the Village in the restoration of the Main Street Cemetery, which dates from 1856. The society is also funding the restoration—and replacement when restoring is not an option—of gravestones and monuments. There is not space enough to list the many accomplishments of the Downers Grove Historical Society. Suffice it to say that the society has been dedicated to the searching out of the history, the preservation of artifacts and the identification of historic sites so that all can know and appreciate the history of Downers Grove.

# BIBLIOGRAPHY

Adams, James Truslow. *The Epic of America*. Boston: Little, Brown & Co., 1932.

Angle, Paul Mc Clelland. *Prairie State: Impressions of Illinois, 1673–1967 by Travelers*. Chicago: University of Illinois Press, 1968.

*Atlas of DuPage County*. 1874 Elgin, Illinois: Thompson Bros. & Burr.

Beggs, Rev. Stephen R. *Pages from the Early History of the West and Northwest*. Cincinnati: Methodist Book Concern, 1868.

Birkbeck, Morris. *Notes on a Journey in America, 1818*. Ann Arbor, MI: University Microfilms, 1968.

Blanchard, Rufus. *History of DuPage County, Illinois*. Chicago: O.L. Baskin & Co., Historical Publishers, 1882.

Blauvelt, Jane. *Who Lived on Maple Avenue?* Downers Grove, IL.: published by Downers Grove Historical Society, 1989.

Breasted, Charles. *Pioneer to the Past*. New York: Charles Scribner's Sons, 1943.

Buck, Solon. *Illinois in 1818*. Chicago: University of Illinois Press, 1967. Reprinted from 1917.

*Chicago-Aurora Centennial, 1864–1964*. Burlington Centennial Book, 1964.

Crook, Richard. *Jesse Walker, Pioneer Preacher*. 1976. Privately Printed.

Dunham, Montrew and Pauline Wandschneider. *Downers Grove 1832–1982*. Dallas, Texas: Taylor Publishing, 1982.

DuPage County, *A Descriptive and Historical Guide 1831–1939*. Re-edited for publication in 1948 by Marion Knoblauch, Elmhurst, Il: Irvin A. Ruby, 1948.

Foster, Vanda, *The Nineteenth Century*. New York: Drama Book Publishers, 1984.

Humphrey; Grace. *Illinois, the Story of a Prairie State*. Indianapolis, IN: Bobbs-Merrill, 1917.

Lester. Katherine Morris and Rose Netzorgkerr. *Historic Costume*. Peoria, IL.: Charles A.

Bennett Co. Inc., 1977.

Quaife, Milo Milton. *Chicago and the Old Northwest (1673–1835)*. Chicago: D. F. Keller & Co., 1923.

Richmond, C.W. & H.F. Vallette. A *History of the County of DuPage, Illinois*. Chicago: Steam Presses of Scripps, Bross & Spears, 1857. (Republished by Caroline Martin Mitchell Museum, The Naperville Heritage Society: Naperville Sun, Naperville, IL., 1974).

Stehney, Virgiania A, *The Downers Grove Fire Department in Its Centennial Year*. Downers Grove , IL: publ by the Downers Grove Historical Society, 1999.

Stehney, Virginia A. and Margaret Phinney. *Firefighting in Downers Grove Over the Years*. Downers Grove, IL.: publ by Downers Grove Historical Society, 1987.

Stevenson, Katherine Cole and H. Ward Jandl. *Houses By Mail*, New York: John Wiley & Sons, Inc., 1986.

Strong, Robert Hale. Ashley Halsey, ed. Chicago: Henry Regnery Co.,1961. *The Prairie State: a documentary history of Illinois*. Robert P. Sutton, ed. Grand Rapids, MI: Eernmans, 1976.

Wiebe, Robert. H. *The Search for Order 1877–1920*, New York: Hill and Wang, 1967.

COLLECTIONS

Letters, Reminiscences and Journals from James Barr, Colonel Wells Blodgett, Cora Blodgett, James Henry Breasted, Lucile Bush, Henry Carpenter, R.O. Curtiss, C.B.&Q Railroad, Maude Lamb Hoover, Grace Littleford Huling, Mrs. Edward Kolor, Mrs. Emma Miller. Plank Road Information, Elbert Rogers, Harriet Strong, and Jack Winter. *Downers Grove Historical Society Collection*.

Letters from Lester Peet, John Richards, and Lucy Narramore Stanley lent by Phyllis Palmer.

PAMPHLETS

Davis, Joseph A. *History of Golf*. Pamphlet, 1975

*History of Downers Grove, centennial*. 1932

*Sears Catalog Home*, Downers Grove Visitors Bureau